D0463613

SEP 30 '81	**DATE DUE**		
JUL 1 3 '83			
JUL 1 3 '83			
JUL 15 '87			

How to take care of
your paintings

How
to
take care
of
your
paintings

by Caroline K. Keck
Illustrations by Ruth Sheetz Eisendrath

Charles Scribner's Sons
New York

To the maintenance and custodial staffs

at

The Brooklyn Museum and The Museum of Modern Art

Library of Congress Cataloging in Publication Data

Keck, Caroline Kohn.
 How to take care of your paintings.

 Published in 1954 under title: How to take care of
your pictures.

 Includes index.
 1. Painting—Conservation and restoration.
I. Title.
ND1640.K4 1978 751.6 77-28085
ISBN 0-684-15551-6
ISBN 0-684-15552-4 (paper)

1 3 5 7 9 11 13 15 17 19 H/C 20 18 16 14 12 10 8 6 4 2

PRINTED IN THE UNITED STATES OF AMERICA

CONTENTS

FOREWORD

Sheldon and Caroline Keck have been for many years the official restorers of paintings for the Brooklyn Museum and the Museum of Modern Art, and more recently for the Solomon R. Guggenheim Museum. Many private collectors and a number of other museums as well have had the benefit of the Kecks' knowledge and skill.

Mrs. Keck has thus had a long and varied experience to draw upon in writing *How to Take Care of Your Paintings*. Presented in simple, nontechnical language, this welcome "primer of practical information" will prove useful not only to the private owners of pictures for whom it was written but to museum curators and their staffs.

<div align="right">

DOROTHY C. MILLER
Curator of the Museum Collections
Museum of Modern Art

JOHN GORDON
Curator of Paintings and Sculpture
The Brooklyn Museum

</div>

ACKNOWLEDGMENTS

On behalf of the Brooklyn Museum and the Museum of Modern Art, I wish to extend special thanks to Mrs. Ruth Sheetz Eisendrath for her kindness in contributing her drawings which play such an important part in clarifying my text. I am also indebted to my husband, Sheldon Keck, who has checked all my information with his eagle eye, and to John Gordon for editing the text and supervising the design. For encouragement and criticism I am indebted to Mrs. Marion Carr, Miss Dorothy Dudley, Mrs. Elizabeth Riefstahl, and Mrs. Carol Kinzel Uht. Last but by no means least I am most grateful to Mrs. Laura Underhill Kohn, my mother, for her facile grandmotherly skill in keeping my young sons from making too great an intrusion on the time it has taken me to complete this primer.

C.K.K.

ACKNOWLEDGMENTS FOR THE NEW EDITION

I would like to acknowledge the suggestions of Jacques Barzun and Mort Waters, my editors for this edition, and the invaluable help of Irma Shaw Cizek and Anna LaRue Bliss. Irm and Nonnie took all my scrawls and read off typescript to one another. The book could not have been completed without them.

C.K.K.

August 1977

CHAPTER ONE

Structural Composition of a Canvas Painting

At the risk of telling you things you already know, let me describe the physical structure of a painting. When students who have never thought of the body beautiful except from the point of view of movie magazines take their first course in anatomy, they get a fresh view of familiar material. They learn that our bodies have skin, muscles, ligaments, nerves, a bloodstream, a skeleton, and so on, as well as attractive or unattractive exteriors. Now books on the history of art and collections of paintings show you all kinds of pictures, in black and white or in color, but the pictures usually have no more than two dimensions: height and width. As you well know, a painting has another dimension, thickness, and that is the dimension that is the most important to the restorer. The purpose of this book is to make you familiar with this dimension.

Third Dimension of a Canvas Painting

Compared to most things around us, a painting has almost no thickness at all (Figures 1 and 2), so perhaps some form of exaggeration is the best way to illustrate the structure. Try to think of a painting as a series of layers, like a well-made bed. Let's pretend the canvas is the mattress, the support on which the rest is piled up. Some artists paint directly on the canvas, without doing anything to it to stop the paint from soaking in, but most artists apply a priming

11

Fig. 1

Fig. 2

coat to seal up the openings between the threads of the material and keep the paint from being absorbed into the fabric. This priming coat could be compared to a mattress protector. (Sometimes artists put a coat of size—glue—on the canvas before the priming layer, the way some people button the mattress into a slipcover before putting down the pad.) Then comes the paint itself. There are many kinds of paint layers, and their uses are as varied as those of sheets and blankets and electric blankets and featherbeds. You may find a simple thin wash of color applied by the artist on top of a primed canvas, or an elaborate underpainting followed by a complicated overpaint, topped off with loaded pigments so thick that the paint sticks out from the canvas. The preference of artists in the application of paint layers can vary every bit as much as beds made up with a single sheet for a hot summer night to many assorted blankets and quilts for a cold winter one. Varnish is applied on top of the paint film to protect the layers beneath, just as a bedspread does. To carry the analogy even further, you can put glass over the painting and a plastic protector over your bedspread.

The Wooden Stretcher

You can also think of the stretcher (Figure 3), the wooden frame on which the painting is supported, as the spring that holds up the mattress and of the bedstead itself as the frame for the painting. This is all exaggeration but has useful points of similarity. For

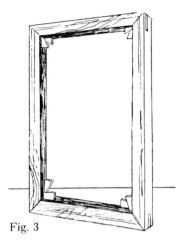

Fig. 3

instance, the spring that holds up a mattress can be nothing more than the hard, tight cloth of an army cot or a deluxe model with perfect hand-tied coils. The wooden stretcher onto which a canvas is tacked is not always a properly constructed frame; it is sometimes a crude quadrilateral with no two sides parallel and no corner a right angle. This can pull the entire painting out of shape and ruin it as a poor spring can spoil a bed, no matter how much trouble you or the artist take with the rest of it.

Canvas and the Priming

Canvases can vary every bit as much as mattresses. Most artists prefer a linen canvas of good strength and appreciable thickness, but artists have painted on many types of fabric. They have used linen as fine as handkerchiefs or as tough as sailcloth; they have used cotton; they have used burlap. Some of our early American painters even used bedticking. If you could look at a magnified cross section of a simple canvas painting, you would see at one edge the threads of the fabric support, which make a pattern in their weave. The layer of size, if there were one, would be invisible, for it has no appreciable thickness, but you could see the priming coat. Although red, yellow, and gray primings have been used at different times during the history of art and now and again are used today, most primings are whitish in color. On top of the priming comes the paint film, and above that the varnish film. Scholars and scientists

13

have studied magnified cross sections of paintings for over fifty years. If you saw one under a microscope, you could identify quite a few of the strata (Figure 4).

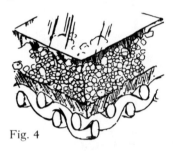

Fig. 4

Pigment

Today, when everything comes bottled and prepared for us, we have a habit of thinking of paint as an entity; it isn't, of course. It is a mixture of at least two things: pigment and a medium. Pigment is the solid-color matter itself and the medium is the fluid substance in which it is carried. The particles of pigment vary in size and form. For clarity, try thinking of paint pigment as stones—which much of it is—varying from the grade of fine sand used in smooth cement to pebbles embedded in a tarred driveway. Keeping this in mind, you won't find it hard to understand that we can take samples of paint color—pigment—and make microchemical analyses to determine what kind of matter it is. In the early days artists ground their own pigments and tried to get them as fine and smooth as possible, but even then they discovered that the degree of fineness achievable was not uniform. If you could see paint samples under high-power magnification, you would be amazed at the difference in the size of the particles composing them. This is the third dimension of paint itself, which we often forget completely. The pigment in paint is a particle of color available for application on the canvas in a medium.

The Medium

There are all kinds of mediums, supposedly to comply with the demands of the artist who wants to paint with a mixture that he can handle to his satisfaction, that will stay put on the canvas, that will dry with reasonable rapidity, and that will not change the appear-

14

ance of the colors as they dry. When you consider the range of these demands, you can see that the choice of a medium and what happens to it with the passage of time are very serious considerations. You can read volumes on the subject of mediums. To list a few briefly, there is watercolor and its several varieties; fresco and its different forms; wax, its most familiar use being perhaps the encaustic portraits of the Fayum period in Egypt; tempera, which includes egg-yolk and egg-white forms and dozens of emulsion mixtures; and oil in all its varieties. For our purpose, it suffices to point out that there are all these mediums and more, but what we are concerned with are the problems they pose in the structure of a painting. A paint film is sometimes referred to as "lean" or "rich," depending upon the relationship in its contents between the medium and the pigment particles. A lean paint film (Figure 5) is one in which the proportion of color particles is much greater, so that when the medium dries out, the paint rests lightly on the canvas like sand on sandpaper, because there is little binding material to hold it

Fig. 5

there. A rich paint film (Figure 6) might be thought of as sand in tar and is about as unsuccessful in drying out properly; a rich paint has a great deal of medium in proportion to the amount of pigment particles held in it.

Fig. 6

Paint Film

Remember the comparison of the paint film to the sheets and blankets on a bed, because this layer can be made up of many different series of applications, of lean and rich paint intermingled or applied at different times, with changes, afterthoughts, or alterations

15

according to the creative instinct of the painter. It can be anything from a very simple thin film to a built-up concoction that would make a banana split with nut ice cream, fudge sauce, whipped cream, and cherry topping seem sparse fare. There is no question that the chemistry of paint is a complex study; we know more than we used to, especially in regard to identification of mediums, but there is ever so much more to learn.

Varnish Film

As a rule, on top of the paint film layer is the varnish. There have been times in the past when varnish wasn't used and there is a feeling against it today, partly because it changes the effect of certain paint films and partly because of a revulsion against the glassy overvarnished surfaces so popular in the last century. I will go into the arguments pro and con later; let it suffice here to say that varnish is a fairly common top layer on a painting.

Structure

So far I have emphasized the various parts that make up a painting, trying to assign to each its separate role. In so doing, I have left the whole structure—the sum of the parts—for last. If the canvas and the priming and the paint films were not all stuck together, all connected layer to layer, there wouldn't be any painting. The cohesion of layers in a painting is usually referred to as its bond. Short of external accidents, the life expectancy of a painting is entirely dependent on the strength of its structural bond, on the capability of the various layers to adhere to one another. The disparate layers have got to stay together. If one begins to move, stretch, or shrink, what will happen to the layers above or below it? Can they hold on to each other, or will they begin to fall apart?

There are a good many sound rules for building up a painting that will be solid in bond, but even when artists follow them the result is not always guaranteed. Like everything else, what will work in one part of the world won't always work in another where conditions are different. For instance, paintings on wood that lasted soundly for centuries in drafty European palaces go to pieces when exposed to the heated conditions of an American house, and likewise a canvas painted in the dry air of Arizona expands and contracts violently in the changing humidity of metropolitan New York until

16

its upper layers of priming and paint film crack and break off under the strain of movement.

How to keep the structure sound, how to make it sound again if it has started to separate, and how to make sure that what you do to it won't make it separate more are the main concerns in preserving paintings. This is what restorers have worked at for years and what scholars are doing research on now. Too many people in the past used to believe that the old adage "Save the surface and you save all" was the rule for preserving a painting, but it is anything but true. Certainly the surface is important; it is the part you look at, where you begin to notice trouble; but never forget the third dimension. Deep down is where the troubles start. Never forget for a moment that behind the surface are all those layers. The survival of a painting depends on the security with which they are bound together, on the stability of the structure.

Aging of a Canvas Painting

From the moment a painting is started, it begins to age, and from the moment it begins to age, it begins to change. In general these changes hold to a pattern that conservators have come to recognize and call normal aging. In the usual type of canvas painting, which we are discussing, the wooden stretcher on which the canvas rests can warp and split, can dry out until it crumbles or breaks apart. Anyone who has ever owned antique furniture knows what a state it can get into. You can do things to it to make it last longer and wear better, but you come to see that wood has a limited lifespan, as does canvas. Owners are often surprised and somewhat skeptical when told that the fabric support of a fifty- or seventy-five-year-old ancestor portrait is desiccated. These same people would think anyone who expected a curtain or a guest towel to last a tenth that long was foolish. No one doubts that the functional life of a fabric is likely to be short, but most people do not appreciate what changes the simple passage of time can make in the canvas support of a painting.

When we come to the next layers in the structure, this is even harder to understand, because changes in the priming, paint film, and varnish layers are often both physical and chemical. Suppose the priming, the filler layer for the fabric threads, is a mixture of whiting and glue. All of us know what happens to glue as it dries out: it doesn't hold anymore; it splits and curls, peels off and powders away. To a lesser degree, age can make a priming layer do

17

the same thing. And most of us have seen what happens to old paint—especially to surfaces that have had more than one layer of paint—how it wrinkles, breaks apart, and peels off. Applying the same kind of comparisons to varnish films, if you consider the care you take with your fine table surfaces to prevent their finish from getting scratched or to keep dampness from marking the gloss with fogged splotches, you will not be surprised at the changes time can inflict on the varnish top of your paintings.

Accidents can happen anywhere, but aging takes place throughout the third dimension of a painting, since all the materials that compose the structure are subject to the ravages of time. You must also realize that a change in one layer can sometimes cause a change straight through the entire painting. What starts to go wrong may be very slight, but the comparison between the relative size of the cause and its effect on the whole painting can be rather like the beginning and end result of an earthquake.

History of Restoration

It is pretty well known today that restoration of paintings has gone on since the beginning of history in one form or another. Some people think that when you tell them that all old paintings have been restored usually not once but several times (or they would not be here today) you are trying to justify this shocking twentieth-century habit of removing the past century's favorite Old Master "glow." That fine old finish is nothing more or less than discolored varnish plus dirt. Of course, there is a catch to it. In the nineteenth century owners got so accustomed to the mellow tone of their uncleaned paintings that obliging restorers often used a tinted varnish to return the surface color to the same tone after cleaning, thus perpetuating the notion of its importance. As parents of young children especially realize, dirt is not necessarily a mark of age. No housekeeper finds the linen more admirable for the dirt it has collected or the furniture more handsome because of a coating of dust. This whole controversy over cleaned and uncleaned masterpieces is an unfortunate sidetrack. A dirty or brownish varnish film has absolutely no effect on the preservation of a painting; it makes it neither go to pieces faster nor last longer. As far as color and tone are concerned, the final surface appearance of a painting, once the artist is no longer present to tell what he or she wants it to be, is a matter of aesthetic preference. But the other issue closely related to this is serious. There are those who hold that the cleaned paintings

have had glazes removed that were part of their original structure and of the artist's intent. Bad restoring, overcleaning, and abrasion are, unfortunately, always with us, as is poor surgery or faulty steelwork or anything else done by inexperienced, lazy, careless, or inferior artisans. Nevertheless, we have today, in some of our great museums, laboratories for the preservation of paintings where each treatment is carefully controlled and checked by every known visual and scientific means, where skilled craftsmen clean paintings of all the accretions and additions that time and interfering hands have added to the original, and where the final surface is left unfalsified. If you could examine this final cleaned surface for yourself under magnification, you would be convinced that this is true. Scientific tests have shown us that not all paintings can be cleaned with safety, that some can endure only minimal cleaning, and that some cannot be cleaned at all. But those paintings that can be cleaned and are treated under expert laboratory conditions are restored close to the state they were in when the artist finished them.

Aesthetics of Cleaning a Painting

How you feel about the effect of cleaning is another matter entirely. This is inevitably swayed by the taste of the period in which you live. This in turn influences your idea of a painting, what you expect it to look like, and this may be quite unlike what it actually *does* look like under its obscuring films. Suppose someone had never seen a cleaned Fra Angelico and that someone else had never seen a dirty one—what utter nonsense it would be for them to discuss the artist's work with each other. Often the shock of the effect of cleaning on the sensibility of the beholder is terrific. A collector will find he liked his painting better dirty, that the forms were more pleasing, the colors blended better, the painting was more harmonious with the room. And why not? It is a matter of preference, of fashion in taste, which has little to do with truth about the original state. Both paintings and children, for instance, originate in a clean state, but by custom there is more or less objection to letting the children get dirty.

Small Troubles and What to Do about Them

Where Your Painting Hangs

The safest place for a painting is on the wall. However, there are places on the wall that are bad for hanging pictures and others that are better, from the viewpoint not of appearance but of preservation. Unless you have your rooms painted or papered much more frequently than most of us can afford, or unless you live in some happy part of the world where dirt is almost unknown, you will recall that the space above a radiator or heat vent shows streaky dirt marks on the surface and is often warm to the hand. Naturally, a painting hanging in such a spot collects this excess of dirt and heat. Heat dries out the material of the painting, speeding up the process of natural aging, and the dirt is deposited on the surface of the picture in an amount far greater than in the rest of the room. Both these unfortunate features apply to that favorite old location above the fireplace. Even the best of fireplaces sends out a certain amount of extra soot, and the chimney flue, however nicely insulated, exudes warmth through the wall. You may decide, as did one delightful gentleman of our acquaintance, that all things considered, he still preferred to hang his fine painting over the fireplace where it had always hung and take it down for periodic cleaning and lining on a short-term schedule. Such a decision is entirely up to the owners, as long as they understand the facts.

The path of a dirt-carrying draft of hot air is not always percepti-

ble. In one museum we were perplexed to find that the whole top edge of a large painting was its dirtier portion (normal conditions would have made the lower edge the dirtier part). A recheck of its hanging position showed an unnoticed hot-air vent across the foyer from the wall on which the painting hung, which was depositing a load of warm airborne dirt directly onto the upper portion of the painting. At that distance it was the dirt rather than the warmth that was detrimental, so the problem was handled by covering the vent with a filter, which held back the dirt.

Dangers of Excess Picture Wire

Assuming that this is the first time you have given thought to the care of the paintings that hang on your walls, there are two other points of danger in that position completely unsuspected by most people. When you hang a painting you occasionally cut a wire too long for the exact position you decide on, or else you move the painting from a spot where the longer wire was appropriate. Many people wind the excess wire back onto itself or twist it into a small snarl and hide the whole mass out of sight behind the painting (Figure 7). As the wire becomes slack, or even from the beginning, it presses against the back of the canvas. The aging process makes the canvas fabric drier and weaker, and the little tangle of wire pushes its way forward, digging into the back of the canvas until you eventually notice a bulge on the surface. Very few people ever connect this with the unfortunate wire hidden from view.

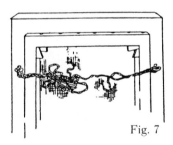

Fig. 7

Dangers in the Method of Hanging

The second danger on the wall is an evil that develops in silence and brings sudden catastrophe. Your insurance adjuster will tell you that the largest percentage of fine arts claims are for paintings

21

damaged by falling off the wall! All the mechanical items—molding hangers, picture hooks, screw-eyes, cords, and wires—all the devices that hold your painting in place, even if these are the best quality, should be periodically checked. Hooks come out of plaster and screws out of wood, wire wears through, and cord rots. Just because your painting hasn't fallen yet, you cannot be sure that it is perfectly safe. Please take the trouble to check; it is a lot less inconvenient than paying for a repair, and no one wants to have a painting damaged.

How to Prepare a Space for Examining Your Painting

Let us say now that for one reason or another you have decided to remove your painting from the wall to examine its condition. Before you do, prepare a space to put it flat. A table large enough to accommodate it is safest and most convenient, but the floor will do. Clear an area somewhat larger than the outer dimensions of the frame and cover it with newspaper or a clean cloth, but be prepared for dirt. If the frame is delicately carved or in any way valuable to you, place two to four cushions at points corresponding to the corners (Figure 8) or projecting sides of the frame so that the weight won't break off a projection or mar the finish on the frame when you turn

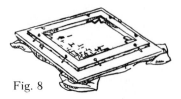

Fig. 8

it face down to remove the painting. In a museum or gallery it is best to prepare four blocks of wood, two-by-four lumber in 12-inch or longer sections, and tack padding over the top sides, covering this with cloth of a close weave (Figure 9). These uniform cushion units save endless wear and tear on frames. Until you have done it ac-

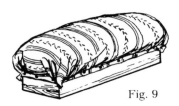

Fig. 9

cidentally, you cannot realize how easy it is to knock a corner off a frame or scratch the finish. Damaging a frame is a lot easier than repairing it.

With all in readiness, carefully remove the painting from the wall —have someone help you if it's heavy or large—and gently lay it face down on the prepared place.

How to Take a Picture Out of Its Frame

Once the frame is safely upside down, direct your attention to removing the painting from it with care and caution. Unless your painting has been replaced in its frame within the past twenty years or so, pause to consider the way it is held in place. You may find that the stretcher is held in position merely by gummed paper; all other means of support have fallen out or broken. Usually you will find nails hammered every which way through the wooden stretcher into the wood of the frame (Figure 10). Remove these *very* carefully, remembering that your painting is on the other side. Only too often it is a physical struggle to get these out.

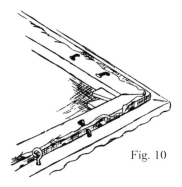

Fig. 10

When you have the painting loose from its frame, resist the temptation to pick it up by curling your fingers around the inside of the stretcher strips; if you do that, the pressure from your knuckles will dent the canvas. Ease the painting out of its frame by its nearest corners, lift them free, and once free remove the painting by holding the palms of your hands against the side edges (Figure 11), the way you would if it were painted on both sides and still wet. Place it upright, lean it against a clear wall space (Figure 12), then place the frame in a similar position, its bottom edge sunk into a pillow or two to protect it and keep it from slipping (Figure 13). Now clean

23

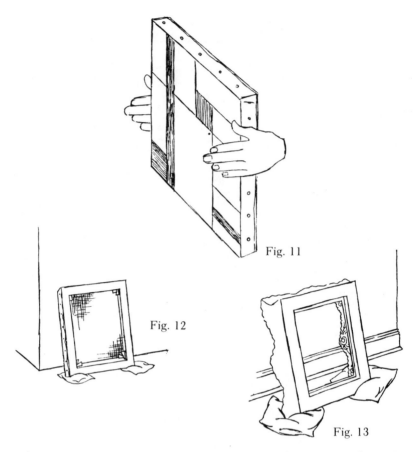

Fig. 11

Fig. 12

Fig. 13

up the space you used; remove the papers, make sure you haven't left any loose nails or tacks or bits of plaster lying about, and for safety, brush off the surface thoroughly. Then put down fresh papers, bring the painting back, and place it *face down* on the smooth, clean surface.

Vacuuming Dirt off the Back of Your Painting

There is one thing you can do at this stage, but you will have to use your judgment about whether it is safe or not. If your painting shows no rip, if it isn't separated from its stretcher, if the paint isn't curling off or the canvas dried out to paper brittleness, you may clean the reverse with the soft brush attachment (Figure 14) of your vacuum cleaner. Should you have any doubts, *don't* do it! But if it seems perfectly safe, go ahead and remove the dirt before it gets

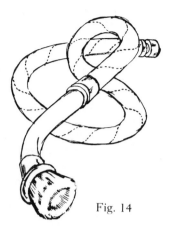

Fig. 14

smeared about the front surface. Pass the little round brush back and forth lightly across the exposed part of the reverse. You will be able to mark the extent of your progress by the change in the appearance of the canvas threads as they get cleaned.

Cleaning Out the "Back Pockets" on a Canvas

Then put the vacuum brush down, stand the painting upright on the table so that the bottom edge is in the air, slant it gently, and tap the stretcher on top. Slant the painting, because all kinds of things may fall out and you don't want them to drop down into the opposite pocket. The part of the canvas between the flat wooden face of the stretcher bar and the turn of the fabric attached to its tacking edge acts as a pocket at the bottom of the painting to catch dust, falling bits of plaster, loose stretcher keys, dried pine needles, pins, tacks, labels, all sorts of objects that you would never believe could lodge there.

People often have a pleasantly decorative habit of festooning frames with evergreens at Christmas. Quantities of the needles fall down behind as they dry, where they rest unsuspected (Figure 15) until their presence makes an obvious bulge along the lower edge of

Fig. 15

the face of the picture. Once I was asked to examine a full-length portrait, recently painted, that had a strange irregularity below the elegantly placed feet. With the help of the butler, the huge portrait was taken off the wall and removed from its frame. When we turned it upside down and tapped gently, out from between the canvas and the stretcher fell a magnificent gold fountain pen! The butler made a surprised noise—it was his, lost for over two years, lost obviously from the day he had helped to hang the painting, when the pen slipped out of his pocket as he adjusted the hooks on the molding.

There is a catchall in your canvas painting similar to a trouser cuff, or the sides and back joints of an upholstered chair, or those annoying corners in the back seat of an automobile. Usually the change in position plus the slight encouragement of a tap will cause the accumulations to drop out, but if you need to ease objects out of this pocket (Figure 16) be very careful to use a flat spatula (Figure 17) or the blunt end of a nail file. Remember that the pocket is very

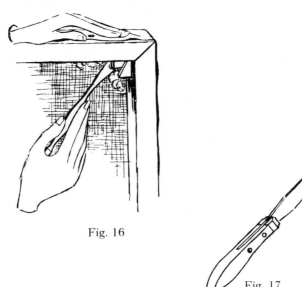

Fig. 16

Fig. 17

flat, and if you push the canvas from the back you are bulging it out in the front and might force paint to flake off or, worse, force the instrument right through the canvas. Continue this process, if you wish, around the other three sides of the painting, where there is naturally less accumulation because of the position of the pocket. Then place the painting back against the wall again while you clean up your working space. Make *sure* that you never lay your painting face down in any loosened dirt.

26

Surface Ripples That Can Be Removed from a Painting

Perhaps what caught your eye were bulges of another type that is quite common in canvas paintings. These may take the form of large ripples all over the painting or a series of pucker ripples that seem to run diagonally, ending at the corners of the picture (Figure 18). These are caused by the fabric of the painting being loose on its stretcher frame, no longer stretched taut. It is a condition that

Fig. 18

should be corrected if it has existed for a reasonable period of time, say more than a few weeks. This reasonable period is important, since sharp changes in humidity affect all materials with hygroscopic properties, and a return to normal atmospheric conditions will correct the expansion of the material. We are talking about a continued, not temporary, state of ripples in your canvas, for aside from being unsightly if left uncared for, these ripples will eventually make the paint surface crack by bending the canvas and the layers it supports. Provided that your painting is not already cracked or torn, this fault is easy to correct.

What Stretcher Keys Are

If the stretcher frame is a proper one, you will note two small wedges of wood nudged into slots at the inner corners where the wooden members are joined to each other. These are the stretcher keys (Figure 19). They are termed *keys* from the meaning of the word "to guide and control," since the dimensions of the stretcher may be changed by their positions. Often these flat wooden triangle wedges are missing, having dropped out somewhere during the life

27

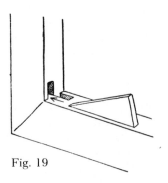

Fig. 19

of the painting. If the keys are gone, you can buy new ones for a few cents at an art supply store—just ask for them by that name—and insert them into the little slots prepared to receive them.

How to "Key Out" a Painting

To key out a painting, first place it face down on a smooth, clean surface and determine whether all the keys are in their proper slots. Then, using a hammer, preferably a flat-sided tack hammer (Figure 20), drive each wedge farther into its slot by hitting the narrow top of the key sharply. Keep your eye on what you are

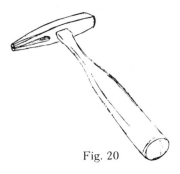

Fig. 20

doing and have someone hold the painting upright if it is easier for you to work in that position. As the key is driven into the slot it forces the joint apart, spreading the wooden strips and enlarging the outer rim of the stretcher, thus stretching your canvas tight once more. There should be two keys in each of the four corners. If your painting is large enough to have crossbars on its stretcher, there may be keys at the joint of the crossbar as well. Hammer them all in tight, having your helper turn the painting carefully, edge over

28

edge, so that the hammer blows are straight down on the tops of the keys (Figure 21). Be careful not to strike the back of the canvas or let the hammer head slip off into the corner. Like anything else, this is a simple thing to do if you know how to handle tools properly. If you don't, find someone who does.

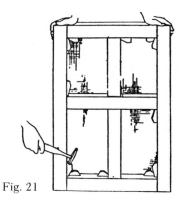

Fig. 21

What to Do When a Stretcher Cannot Be Keyed

Not all canvas paintings are stretched on proper stretchers. Artists are proverbially poor and occasionally careless in how they put a painting together. Some stretchers—or strainers, as they are correctly called in this case—are not made to expand (Figure 22). They are nailed together at the corners and cannot be enlarged. If you find that the stretcher on which your painting rests cannot be keyed

Fig. 22

29

out and there are surface ripples due to expansion of the canvas, the only permanent remedy is to have the painting restretched on a stretcher fitted with keys. Unless the canvas is strong and the work is done by skilled hands, the painting will not survive the treatment undamaged.

When canvas is originally stretched, its fabric is pulled tight against the outer limits of the wooden stretcher and tacked fast where it is pulled over the edges of the strips. The excess fabric, which is held to pull on, is called the tacking margin. It is usually trimmed off so that what is left to overlap is rarely more than the width of the side of the stretcher strip (Figure 23). This is called the tacking edge. As you can see, it doesn't give you much to hang on to

Fig. 23

for pulling tight when you restretch. Besides, if the canvas has aged and the fabric is at all dried out, there is always the danger that the tacking edge will split at the bend or even tear off in your hand if you try to pull it tight again. Restretching your painting from an improper, broken, or inaccurate stretcher onto a correct one is a procedure I do not advise you to attempt on your own. It is not uncommon for restorers to restretch paintings, but usually the paintings are less than twenty years old or in extremely sound and strong condition. Even then, it is safest to coat the edges of the new stretcher with a wax adhesive to help strengthen the tacking edge and keep it from splitting. It is a painstaking job.

How to Remove Isolated Dents and Bulges from a Canvas

There is a simple remedy for another type of bulge in a painting, the kind caused by pressure against the back of the canvas, such as

the excess of forgotten wire mentioned earlier. When such pressure has been of long duration, it leaves the canvas bulged out even after the pressure has been removed. You can flatten the surface again by dampening the reverse of the canvas where the irregularity shows and drying it under weights. Doing this is always risky, because only a carefully trained and experienced craftsman can tell when contact with water will have a disastrous effect. If you want to take the chance, however, this is how you do it.

Place the painting face down on a clean, flat surface. Have a piece of waxed paper either over the entire working space under the painting or at least over the area where the dent or bump will rest. The waxed paper is put next to the painted surface to protect it from sticking to the newspaper covering your working space, or any other surface it rests against while you are repairing the reverse. Dip a small sponge or a wad of absorbent cotton into clean water, wring it almost dry, and gently moisten the back of the canvas (Figure 24) where the irregularity exists. You can tell when you have done this

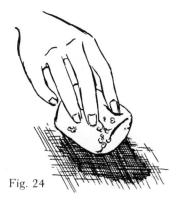

Fig. 24

correctly because the dampness darkens the tone of the canvas. *Don't* leave drops of water on it: the sponge should be squeezed enough so that there is no excess. Be sure to dampen the area sufficiently so that you won't have to do the whole thing over again because all of the bulged section wasn't wetted. Cut a large, clean white blotter to a size that will more than cover the entire area you have dampened and place it there. On top of this lay a flat surface of about the same size as the blotter. (I keep dozens of little squares prepared for this purpose, some glass and some smooth Masonite.) In an emergency you can use a book with a smooth flat cover. *Do not* use any textured or rippled surface, since this will force its own impression into the dampened canvas and do more harm than good. On top of this flat surface place a considerable weight—a doorstop

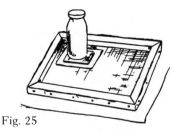

Fig. 25

or a heavy bookend or a jar of nails (Figure 25). Whatever you use, make sure it won't topple over and fall onto the exposed portion of the canvas. I use prepared weights made by filling gallon jars with water. In about half an hour take all these objects off and change the now dampened blotter, putting a dry one in its place and piling up the pressure again, carefully and correctly as before. Change the blotter after another half hour and again every half hour until the canvas has dried where you dampened it.

After it is completely dry, leave the whole under pressure with a fresh, dry blotter against the canvas for another twelve hours for good measure. Nine times out of ten the bulge is completely gone after this treatment. *Caution*: Don't forget to have the working space perfectly clean and smooth; don't forget to put waxed paper in front of the face of the painting; don't forget to put the blotter down first next to the dampened spot of canvas; and don't forget to put the flat surface down next to the blotter *before* the weight. The blotter has not only to absorb the dampness slowly but also to cushion the outlines of the applied pressure so that it won't leave marks on the canvas. Putting down the flat surface next is important because then it doesn't matter what kind of bottom the weight has and, oddly enough, so many objects available as weights have such strangely bumpy bottoms.

CHAPTER THREE

Cleaning a Painting on Your Own

Now we come to the question almost everyone wants answered: If your painting has a dirty surface, how can you clean it yourself? There is no simple answer, because sometimes you can do this quite successfully and sometimes you can ruin your painting. There are so many variables: the kind of medium used by the artist and its current condition; the nature and state of the varnish, if any; the chemical or physical deterioration of the structure. If you are worried at all, don't try it. But because there are times when people do want to clean paintings and there are so many ideas about cleaning them, I will tell you some ways it can be done but guarantee the results of none. This isn't as harsh as it may sound. Think of an ordinary stomachache. Maybe all you need is bicarbonate of soda or a cathartic or a hot-water bottle or a little rubbing of the abdomen—but then think what might happen if you tried these remedies and the stomachache turned out to be an attack of appendicitis. Hence a warning (in big red letters): *clean your painting at your own risk!*

What Superficial Cleaning Involves

There are many kinds of dirt and many ways it is found on paintings. In most of our big cities the air carries a heavy load of greasy soot. It is the type of black deposit you wipe off a windowsill—gritty

and smeary. If your painting has a varnish coat, this dirt may lie on top of the varnish and be fairly easy to remove without disturbing the varnish itself. This is called superficial cleaning, and there are several ways you may perform it. You may use a mixture of equal parts of rectified spirits of turpentine and petroleum naphtha or use one of the white cream furniture polishes that consist of a wax emulsion in water. (Make certain the cream polish you buy is for use on furniture only and *not* to remove tough stains from porcelain. If by error you use a white emulsion cleaner destined for kitchen or bathroom efficacy, it will eat straight through your painting and destroy the picture.) You may also use a noncaustic soapless detergent powder, many of which are on the market. These should be mixed with water in a proportion of 100 to 1, that is, a 1 percent solution. It is wiser to use a cleaning solution that is consistently mild, such as the suggested detergent powder in water. When people clean a painting with water and a cake of soap, they always feel that if a little dab of soap works well, a little more soap will work even better. This can lead to catastrophe, the dissolution of part or all of your painting. If you have ever left a damp cake of soap on a painted surface in the kitchen, you know how it can eat into the paint. It can do this even faster on your painting.

How to Support a Painting during Cleaning

Just as you fit a darning egg inside a sock while it is being mended, you should support a canvas from behind to prevent its surface from sagging under the pressure of cleaning. Just as with the darning egg, the support will make it easier for you to do a good job. Without it, the cleaning pressures could crack the layers and seriously weaken their bonding. Examine the surface thoroughly to make sure it is sound before you consider cleaning your painting. Then choose the best supports you can find and fit them carefully into the empty spaces under the painting between the members of the stretcher (Figure 26). The support should be of the right thickness to allow the canvas to lie flat during cleaning. Flat blocks of

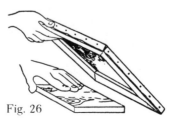

Fig. 26

plywood cut to size are excellent, but you can substitute a series of built-up cardboards or even magazines if you must. Be careful not to build a disjointed or irregular collection, or the marks of their disparate edges will be impressed on the face of the painting as you clean it, much the way they would be if a tablecloth were ironed on such a surface.

How to Go about the Cleaning

Get a good supply of the best absorbent cotton, a wastebasket for the disposal of the dirty wet swabs, and a clean glass large enough for your hand to fit into. Fill the glass half full of the cleaning mixture you decide on. Make sure you have plenty of working room, so that you won't knock over the glass by accident and drench everything. Dip a small wad of the absorbent cotton into the cleaning mixture and squeeze it almost dry. Start at an edge of the painting where you will do the least damage if things go wrong and gently rub the swab over a small area to see if the dirt will come away. Often there is a narrow strip along the edge of the picture that remains clean because it is protected by the frame; this area will give you a notion of what the colors were like before they got dirty and will act as your guide. If your test cleaning satisfies you, take a second swab of cotton, dip, squeeze, and rub gently on another section of the painting, making sure that your support is directly under the section you work on. Each time you clean, take a dry swab and wipe all the dirty dampness off the surface so that the cleaning solution never stays on the painting longer than it must. It is wise to start your real cleaning in some white or light area—if it is a portrait, a collar, shirt, or hand; if it is a landscape, a white cloud or building—and do one part of the painting at a time in isolated sections. It is best to clean the least important parts first. Wait until you have the feel of the thing before you go to a face or the main interest of the painting. In every case, proceed with your heart in your mouth but don't swallow (Figure 27).

Not All Colors in a Painting Clean the Same Way

Certain colors seem more solid than others. White and mixtures with white are fairly firm, reds and greens vary, yellows and oranges are sensitive, and black is very touchy. Especially in nineteenth-century American portraits you will find that the darks

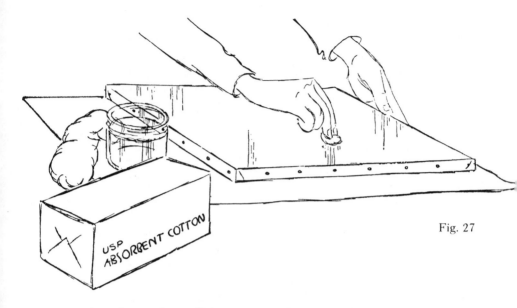

Fig. 27

USP
ABSORBENT COTTON

have been "skinned" by previous cleaning and are very thin or even lost and repainted. Once a woman in Brooklyn was cleaning the portrait of her grandmother as a little girl—very cute she was, too, in a scotch plaid dress holding a fluffy dog. She started on the face, got the dirt off wonderfully from one round little cheek, and then boldly swabbed her soapy cotton across the eyes. In one fell swoop she took off the black pupils and the eyebrows. Don't take the risk of this happening.

A Badly Cracked Surface Is Dangerous to Clean

Cracks are always present in a painting even if you can't see them with the naked eye. No matter what cleaning mixture you use, if you get the surface too wet, the wetness will seep down through the cracks into the structure and tend to loosen the bonds between the various layers of the painting. Even if you have examined the surface first, you may not have noticed how much cracking is there. Sometimes as you clean you may find that bits of cotton get caught in the surface. These may be snagged on high parts of the paint film, the impasto, but they may also be caught in the rough edges of tiny cracks. Remove the fluff with great care—use a pair of tweezers —so that you don't pull off any of the surface. If bits of your painting should come away, you had better ask a trained person to finish the cleaning.

Unvarnished Paintings Are a Special Problem

A great many paintings were never varnished. Many people have portraits of ancestors made by those beloved itinerant painters who produced such fascinating American folk art portraiture. Those artists worked swiftly and had to move on long before their portraits were dry enough to be varnished safely. Many of the owners were too busy or never realized that the paintings would have been safer with a varnish protection against airborne dirt. This accounts for the vast number of soiled, unvarnished paintings that have had such trying histories. When such paintings were cleaned in the past, the embedded dirt invited scrubbing, and anything strong enough to loosen it usually took along some of the paint. What had been "lost in the wash" was painted back in again with a rather free hand. The portrait became the work of two hands, the artist's and that of the well-meaning soul who "restored" it, and by then it looked a good bit less like the person who posed for it. If you suspect this condition in your portrait painting, better not try to clean it yourself.

How to Recognize Repaint

Old repaint is not always simple to recognize without technical aids, which will be discussed later. But if you find patches on the reverse, you are likely to have a corresponding repair on the surface of your painting. The repair may no longer match the colors surrounding it. Oil paint darkens with age. Replacing lost paint—inpainting, as it is called—must be kept lighter than the tone it joins or else it will soon be too dark, because it started life darker than the original did. Often dirt has obscured the difference between the darker tone of the repaint and the lighter one of the original surface. When you have finished cleaning the picture, you may be horrified at the splotchy effect that wasn't there before. Of course it was there, but a thick film of dirt can cover a multitude of unpleasant changes.

Cleaning Paintings with Onions and Potatoes

Because there has been so much talk about cleaning paintings with onions and potatoes (Figure 28), I wish to report that I have

37

Fig. 28

tried these two materials and that they do clean off the surface dirt. However, they do it less effectively than other materials, and the hard texture of both cut onions and cut potatoes is rougher and tougher on the surface of a painting than that of a swab of absorbent cotton. In tests with both vegetables I found it necessary to wipe off the film they leave on the surface, so that cotton swabs were used anyway. I had a notion that onions and potatoes might even clean small children, but violent protests prevented me from making any prolonged tests in this field.

Bottled Preparations for Cleaning Paintings

There are various preparations on the market for cleaning paintings. Tests have shown that several of these prepared mixtures will clean the surface of a painting without disturbing an old, well-hardened varnish film but that they will soften varnish that is fairly recent. A softened varnish will catch and retain all the fibers it can grab from a cotton swab. The only solution for this unsightly mess is complete removal of the varnish. Some bottled cleaning solutions do take off varnish, but with these you run the risk of discovering that the solution will also remove the paint beneath. Different varnishes have differing solubilities and so, alas for their safety, do paint layers. Read the label on any preparation you decide to buy. It should tell you what to expect, whether it is concocted to dissolve varnish or merely to enable you to clean dirt off a varnish surface. Manufacturers seldom invite trouble; their labeling is reasonably reliable. Should you elect to make use of a bottled preparation, the same procedure is advised in cleaning and the same warnings hold true. Make a small test cleaning and don't let the mixture stay on the surface for any length of time. If anything starts to go wrong, stop at once. Unless you are very confident of your skill, it is better not to try the preparations that will remove the

varnish. You may be perfectly successful, but you may also ruin your painting. Whatever you use, go *very* slowly.

If you have employed the wax-emulsion type of cleaner, after the job is done and the excess wiped dry, the slight film of wax left on the surface of the painting can be polished with a clean silk cloth or with a clean soft brush (Figure 29) of the kind used to shine shoes. Do this very gently, making sure the supports are still behind the canvas to protect it from the strain of the brushing pressure. When either the naphtha-turpentine mixture or a detergent solution in water has been used, the cleaned surface is often dull in appearance and will need an addition of varnish to make it look pleasing again.

Fig. 29

CHAPTER FOUR

Varnishing and Other Finishing Touches

One of the most common causes of worry over a painting when nothing else is wrong with it is the varnish surface. This final film applied to the surface as a protection or to give it greater brilliance can change in many ways without leaving any noticeable effect on the painting beneath it. Besides the dirt it can collect and the change in color as it yellows with age, varnish can become webbed with tiny disfiguring cracks and even become milky in appearance so that the painting beneath is almost obscured from view. This last change, called bloom, is caused by the penetration of water vapor into the varnish. Unless it has been present long enough to have changed the nature of the varnish, it can be removed without much difficulty.

How to Remove Bloom from a Varnish Surface

Bloom may be removed by waxing the surface with a fine-quality paste wax. Get the best quality of paste wax recommended for use on furniture. Be careful to make sure it is *not* an emulsion of wax and water, because in that form it will not serve your needs. Check the condition of your painting by examining it carefully in a good light to make certain there is no loose paint or weakened areas on the surface. Support the back of the canvas with the blocks of plywood or stacked cardboards as advised for cleaning so that the

pressure of waxing will not make the canvas sag and crack the paint films. Take a small amount of the paste wax on a clean cloth or cotton swab and gently rub it into the milky surface. Keep rubbing the wax in until all the bloom has disappeared. Then wipe off the excess wax and polish what is left with a soft-bristle brush or, if you prefer, a dry silk cloth. If you are going to leave the wax on the surface, hold the painting up in the position it will hang in the room to decide which direction of finishing brushstrokes, horizontal or vertical, gives the more pleasant effect. This will depend, as you will see, on the way the light strikes the painting as you look at it in its hanging position. Keeping your final brushstrokes parallel, you can give the painting the surface reflectance that is most pleasing to you. A waxed varnish does not bloom, but its finish is not pleasing to everyone, and wax does catch dust.

Revarnishing

If you have just cleaned your painting, using either a mixture of turpentine and petroleum naphtha or one of the detergent powders in water, you will probably find that the surface has a dull, uneven reflection. This can be taken care of by applying a fresh coat of varnish to rejuvenate the old film and return it to brilliant transparency. There are a great many picture varnishes on the market, but make sure when you select one that it is a varnish intended for use on a painting and *not* on a floor. Our forefathers occasionally made the grave error of coating their pictures with coach varnish—an oil-type varnish similar to that used on floors—which hardens close to insolubility. What you want to buy is a *spirit* varnish, the resin of which is soluble in solvents that do not act on dry oil paint. A dealer in artists' materials will help you select an appropriate varnish and a brush for its application and give you advice on how to proceed. See to it that the day you pick for varnishing is a dry one and that the room in which your painting is to be varnished and where you will leave it to dry is comparatively free of dust.

Synthetic and "Natural Resin" Varnishes

Twenty years ago the majority of varnishes available for your needs would have been based on damar or mastic resins in various vehicles. Today the majority of picture varnishes offered for sale are

based on synthetic resins. Predominantly forms of vinylite, metha-crylates, and acryloids, these varnishes are sold under trade names or letters of the alphabet followed by numbers. Be governed in your selection by the kind of solvent mentioned on the label as correct for diluting the mixture. Stick to the varnishes that can be thinned with turpentine, naphtha, mineral thinners, and petroleum benzine. Avoid those that require xylene or toluene for further diluting. You may brush the varnish on your painting or spray it on. Remember, with newly painted pictures it is customary to wait a year to allow the paint to dry sufficiently before varnishing.

To Varnish or Not to Varnish

This brings us to a great controversy among both artists and laymen—to varnish or not to varnish. In many oil paintings of the twentieth century the effect desired by the artist is a mat or unshiny surface. To leave these paintings without protection is to condemn them to an early death. Dirt can rarely if ever be removed from the interstices of an unvarnished painting without loss of paint, and a painting left to grow dirtier and dirtier in time no longer has much resemblance to the original. Some people who are violent about aesthetic values don't care whether a picture lasts, if they can enjoy it correctly while it does. As long as they have no illusions about the inevitable, their preference is a personal matter. But unless paintings finished mat are kept behind glass or in dirt-controlled atmospheres, it is wise to compromise on their appearance and protect the surface with a thin, quick-drying dull varnish. Museums have found that one of the best ways to solve this problem is to have the surfaces of mat paintings sprayed with a very dilute mixture of one of the synthetic varnishes in a quick-drying solvent. This powders the painting with such minute particles of transparent protection that the change they effect is barely visible. I know this does the protective job it is intended to do because I sprayed such a film on an almost all-white mat-surfaced painting that hung in a New York office. After three years there it had collected enough dirt to require cleaning. I removed the sprayed varnish with the dirt that had lodged in it and resurfaced the painting with the same material, to the complete delight not only of the owner but also of the artist. The pristine whiteness of the painting offered an extreme case and an excellent example of the wisdom of protection.

The Right and Wrong Paths

No varnish is absolutely perfect. None should be expected to last forever. What I prefer is a coating that will dry hard enough to isolate dust and grime from the paint layer, one that will discolor as little as possible, that will not be permeated by dampness, and that can be removed easily with mild solvents. Many of the available synthetics combine the best qualities of the natural resin varnishes without including their faults. And faults they had—in early yellowing, intricate crackle patterns, and pronounced liability to bloom. Aged mastic and damar coatings remained soluble, not, as they oxidized, soluble in the turpentine-petroleum-naphtha group in which they could initially be applied, but soluble in a slightly more active group of chemicals. The majority of synthetic varnishes remain reversible: they may be removed with the identical vehicle that diluted them for application. Those not accurately termed *reversible* may be removed with the same range of solvents employed to remove polymerized natural resin coatings. Like paint mediums, each variety of varnish, natural or synthetic, has its advocates and detractors. It should, however, be admitted that the use of synthetic varnishes invites fewer, not greater, risks to the paintings they cover.

Much advice given in the past has been harmful. It is difficult to understand the origin of some of the strange beliefs regarding the "feeding" of a painting. All too often, when this term has been used, the instruction that accompanied it involved drenching the surface of a picture with some nondrying oil. When a coating of this type is put over a picture that has dried out and gone dull, the immediate effect is a return to visible brilliance. This apparent improvement is short-lived, however, and its use can have tragic results. I have seen canvas paintings "fed" with petroleum jelly or olive oil that were stained black past all rescue. Such substances present sticky surfaces to attract dust and grime; in cracked or absorbent structures they carry their accumulations, penetrating the interior layers of paint, priming, and fabric, irrevocably darkening all. Drying oils such as linseed, walnut, and poppy and varnishes made from them are also unwise to use. They not only darken excessively as they age but also form a coating film that becomes so hard that very strong solvents are required for its removal—which is sometimes impossible to do without damaging the paint surface beneath. Balsams, often sold under claims as varnish rejuvenators, are not recommended, because they darken swiftly and afford no additional protection. If the

varnish surface on your painting is greatly discolored, crystallized, or generally displeasing, it is wise to have it removed. Do not try to do this yourself, but take it to a well-trained technician.

How to Attach a Painting to Its Frame

Assuming that you have now completed all the treatment your painting needed, you will be eager to get it back on the wall. If you applied varnish, make sure it is dry before attempting to reframe the painting. When a picture is returned to its frame or placed in one for the first time, it should be fastened there securely. If you have had occasion to remove it yourself and have found the customary nails, I hope you have developed a prejudice against this form of attachment. It takes hammering to put nails in and wrenching to pull them out, and at best they are none too permanent under strain. At most hardware stores or counters you will find metal straps 2 to 4 inches long, called mending plates, drilled at either end (Figure 30). With these, buy $\frac{5}{8}$- or $\frac{3}{4}$-inch screws to fit the drilled holes. These little brass straps can be bent easily, so they can

Fig. 30

be adjusted, one end flat on the wood of the frame and the other end flat against the wood of the stretcher. Four of these are usually enough to hold, but use as many as the size of the painting demands. Screw them in place at the top and bottom of the frame and on the sides as well, if you wish. They will hold the picture safely in place. This is a very simple procedure that spares the painting from the dangers of hammer blows and makes it simpler the next time you want to remove the picture from its frame.

Protection for the Back of Your Painting

Perhaps the most profitable protection you can give your painting is something so simple that, once you have learned about it, it seems ridiculous that every canvas painting isn't equipped with it. This is a cardboard backing for the reverse of the stretcher (Figure 31). It keeps out dirt, prevents anyone from marking or placing a label on the back of the canvas, and acts as a guard to ward off damage from the back side of the picture. The cardboard should be strong

44

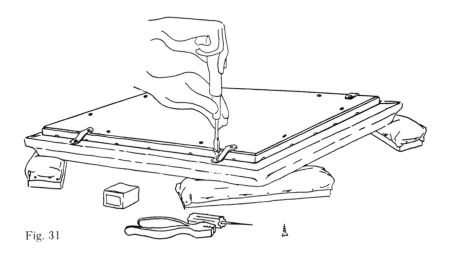

Fig. 31

and firm. The corrugated kind is no good, since it punctures too easily. You can buy process board at an art supply store. There are many varieties; select one of satisfactory thickness and rigidity, in a size adequate to cover the back of a normal-size painting. For larger paintings several board sections, bridged between the stretcher crossbars, will be required to cover the exposed canvas. On small paintings cut the cardboard to measurements $\frac{1}{2}$ inch scant of the outside dimensions of the stretcher. On larger paintings cut the sections so that they overlap the stretcher members by a good inch on all sides. You must provide at least enough overlap to attach the cardboard with screws through the cardboard into the wooden stretcher frame. The easiest way to cut the cardboard is to measure for the size you need, draw guidelines, and then groove the board along the lines with a sharp knife, cutting deeply enough so that the excess piece can be broken off by bending it up and down (Figure 32). The small amount of time and expense this backing costs is repaid a hundredfold in the protection it affords the painting.

Fig. 32

Things to Remember about Frames

Framing is a very personal matter, but there are certain points to keep in mind. A frame should be large enough to receive a painting and permit it to be keyed out when necessary. It should also be in sound condition; the painting should not be expected to hold the frame together. If you want to show the full view of the painting and not have its edges covered by the inner rim, or rabbet, of the frame, don't expect the brass straps to be strong enough to keep it from falling through the frame opening! To frame a painting for full view safely, it is necessary to enlarge its outer dimensions by adding to the tacking edges of the stretcher wooden strips ¼ to ½ inch wide. Screwed securely in place, these strips can rest against the rabbet of the frame, substituting for the rim of the picture, which would normally rest there. Enlarging strips, as the name suggests, are also used for securing a painting in a frame that has an opening too big for it. Under all circumstances, a painting is framed correctly (from the physical standpoint) only when it is placed in a true plane, without warp, strain, or pressure, and firmly held.

Showing Paintings without Frames

There is an occasional preference for showing modern paintings without frames, covering the tacking edges of their stretchers with fabric masking tape for neatness (Figure 33) and putting screw-eyes

Fig. 33

for hanging directly into the back of the wooden stretcher. As long as the stretcher is sound, this is quite permissible for room and exhibition use, but a painting so treated is bound to receive damaging wear and tear if it travels about. No painting should ever be subjected to a tour without the protection of at least a strip frame of wood or metal screwed into the tacking edge of the stretcher and overlapping the front face of the painting by at least ¼ inch (Figure 34). Naturally, the reverse should have a cardboard backing (Figure 35). Canvas is very easily worn and torn where the fabric

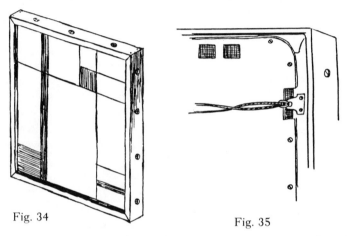

Fig. 34

Fig. 35

bends over the rim of the stretcher along the tacking edge. Once this has happened, puckers form in the loosened parts and any slight mishandling may result in a serious rip well into the fabric on the front face of the painting. When a painting is moved about, the brunt of the contacts is always on its edges. To expect them to stand up with nothing more than fabric tape over them is like expecting a blow not to hurt the funny bone in the elbow because a cloth sleeve covers it.

Hanging the Painting Back on the Wall

Where and how a painting is hung has a lot to do with its preservation. As mentioned, the spot over the fireplace is a favorite one but it exposes the painting to an excess of soot and heat; the same holds true of a wall space over a radiator or hot-air vent. There are always some locations in a room that, however attractive they may be aesthetically, have the undesirable characteristics of exposing a painting to excess dirt, heat, or dampness. Also not to be ignored is

excess light, let alone direct sunlight, which submits a painting to the destructive elements of photochemical reactions. If you are considering the preservation of your paintings, avoid locations with known hazards or take precautions to minimize their harmfulness. Shields can be installed to deflect emissions from heating units, and windows can be shaded. These are small points of attention that ensure big rewards in longevity.

The wires and hardware used to hang a picture should be strong enough to carry the weight and a little more. Play safe—use larger rather than smaller screw-eyes, heavier wire, and stronger molding hooks or wall hooks. Whenever a painting is taken down, test the hooks before it is rehung; test the wire and the screw-eyes as well. If you are replacing screw-eyes, do not use the same holes unless you are filling them with bigger screw-eyes. Make a small start for the new hole with an awl, gently applied. Remember that screws go into rotten wood easily but work out even more easily—and very unexpectedly.

Frames should never be painted with the pictures still in them, a caution that seems self-explanatory but is all too often overlooked. Spatter marks on a painting are difficult to take off, and flecks of gold paint are seldom soluble. The faces of some paintings bear evidence of ill treatment—splashes from a series of wall repairs as well as frame repairs. Dust may be removed from both the frame and the painting, something best done by the owner or someone equally responsible. Use a soft-bristle brush (Figure 36) on the surface of the painting, with light parallel strokes.

Fig. 36

The frame on a framed painting can be cleaned with the vacuum cleaner extension or with a soft brush. Do this carefully; the picture is close by. Be especially gentle when cleaning a frame with delicate or elaborate decorations. Any careless pressure will break off sections, which usually shatter to bits as they hit the floor. Frame repairs are time-consuming and can be costly.

Stiff brushes, dust cloths, and oily or wet rags should never be used on the surface of a picture and are better not used on the frame around it.

Try to check the hanging of your paintings at least once a year, as I said before. The vibration caused by traffic can loosen many fasteners that otherwise appear to be permanent. There is really no such thing as a permanently safe hanging for a picture.

A Few Warnings about Prints and Watercolors

While discussing permanence, let me mention fine prints, water-colors, and drawings. Some people have a tendency to treat anything on paper as if it were a reproduction. Watercolors, drawings, gouaches, and prints must be kept behind glass if they are to last in a reasonable semblance of their original state. If you care for what you are putting under glass, have a mat to keep the glass from coming into direct contact with the design on paper. There is always the danger that pressure from the glass will catch and hold some of the surface, if not the paper as well. All mats should be made from chemically pure matboard; there is no excuse whatsoever for any framer using an acid-pulp mat that will discolor and dis-integrate your work of art on paper. The difference in cost is minimal.

No work of art on paper should be stuck solid to a mount if it is at all possible to hinge it to an inert support. Short of repair for a disaster, paper items should be allowed freedom, be held lightly in place, and be easily removable. Hinging is best accomplished with Japan tissues and water-soluble paste, but even store-gummed paper is preferable to any form of Scotch tape. *Never* use Scotch tape or rubber cement on any portion of a valued paper item; the materials seriously discolor paper and their adhesive is exceptionally difficult to remove. In many cases the potent chemicals required to effect the removal of the sticky adhesive and decrease its inevitable stain sub-ject the design to acute risk. If you are determined to repair a torn edge of a paper artifact, use Japan tissue applied with thinned rice or starch paste and dry out your repair between blotters under weights. The restoration of tears in the paper support of a design is quite delicate and should be performed by a professional. In this kind of picture there are only two layers: the support, which is paper; and the design, which is an addition but uses part of the paper in many instances. The aesthetic harm, let alone decrease in value, that ensues from inept restorations in works of art on paper is more complex to correct than in almost any other form of creative art.

If you are taking your print, drawing, or watercolor to a framer,

do *not* allow the edges of the original paper to be cut off, since this destroys the full value of the piece if you should ever wish to sell it. When it comes to hanging your framed and glazed work of art on paper, give serious thought to the hazards of its positioning. Paper is ultrasensitive to excesses of heat and light: it rapidly embrittles to powder, and the colors in designs fade in obvious change. Some curators feel that no print, drawing, or watercolor should be left in a position of display for more than a short time but should be alternated and replaced so that each rests out of the light for a few months every year. There are even those who believe that Japanese prints should never be exposed at all! It seems more intelligent to me to compromise with perfection but also to be fully aware that permanent preservation is a figment of the imagination.

The Question of Lighting

For lighting a picture, specialists in the field offer many suggestions. If you choose individual picture lights, make sure the bulb will not be so close that the heat from it will tend to bake the surface of the painting. Although this is uncommon, I have seen examples in which the disfiguring crackle of varnish and paint films has formed in an area steadily exposed to an overhanging picture light. The cooler bulbs make this a less likely hazard, but emanations from fluorescent fixtures have a high percentage of ultraviolet, considered a cause of fading. Any form of attached light should be used only as needed; turn it on for given occasions and don't forget to turn it off. Also give thought to the cord connecting the light to the outlet. If you have placed a cardboard backing on your painting, there is no particular danger. Without a cardboard backing to shield the fabric, the electric cord can kink and twist and press against the reverse of the painting until, like excessive picture wire, it can push the front quite out of plane. The protection of a cardboard backing cannot be overemphasized.

Familiar Misfortunes and How to Prevent Some of Them

When a painting falls off the wall, the best thing you may expect is that it should show no apparent damage. In such cases there has been a shock to the structure, but the fall may never show any effect or may show its effect later on, when cracks develop faster or more extensively than they might otherwise have. The worst thing is to have the painting fall on some pointed object that rips through its fabric. There are all kinds of rips and tears suffered by paintings: big rips and little ones, tears that are clean-cut and others where the rip has frayed and shredded the canvas support so that any thought of re-forming a structure out of the mess seems fantastic. Aside from the punctures, you may find scratches and abraded places where the paint has been rubbed off as well. All these are serious forms of damage. If your paintings are insured, report any damage to your agent. If someone can't come around at once to see what has happened, have the damage photographed so you can show exactly what it looked like before you undertook to have it repaired. It is important to have everything proper in the record if you want to collect from the company.

How to Give First Aid to a Torn Painting

I am often asked if it is all right to make a temporary repair of a tear in a painting with adhesive or masking tape. I believe that

unless you are so situated that you can have the damage treated promptly by experienced hands, such a repair is not only wise but necessary first aid. If the tear is T- or L-shaped and is ignored for any length of time, the free corners of the tear will curl (Figure 37). As the canvas curls, all the layers on top of it become distorted and

Fig. 37

cracks form, bonds break, and the layers begin to flake off, so that you have partial or complete loss of those parts of the picture that curled, as well as the puncture damage.

Directions for making a temporary repair of a torn area start with the familiar exhortation to prepare a space to work in and make sure it is flat and clean. Put down a sheet of smooth paper, preferably glassine paper, and place your damaged painting face down on top of it. Make your repair with a gentle tape at least 1 inch wide of the kind you can tear with your fingernail, one that has a non-water-soluble adhesive. (This is a moment when you do not want to get the canvas wet and encourage any further movement in the fabric support.) You can use adhesive tape, masking tape, decorator's tape, or any such tape that you can easily tear by hand, all readily available at stationery counters. Cut some pieces for use before you start. Don't work from the roll itself, because you are apt to pull your repair out of shape when you cut off the extra tape. If the tear is small, flatten the little break back into plane with your hand and gently pat on the mending tape along the line of the tear (Figure 38). If it is too big to mend in one fell swoop, try easing the worst sections

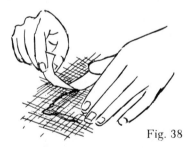

Fig. 38

back into place with a series of little tape bridges, confirming the join of the torn extremities before you concentrate on the middle section. Don't rush; press your mending tapes lightly until you achieve a joining you like, shifting tapes if need be. The sides of a bad tear do not always expand uniformly. Check with the design on the face of

the painting to see if its parts are as closely aligned as you can get them. On a large rupture it may be helpful to rejoin temporarily with the painting upright and a helper holding the torn fabric together with a palm of the hand on each side of the painting.

After you have reunited, as best you can, the important design pattern of the picture, lay the painting face down and confirm your emergency repair. On bulging portions of a complicated tear, use light weights—a sandbag or a small purse—to afford control over the outlying sections while you concentrate on fixing the epicenter. Don't fret over any small dents or ripples in the whole; they can be attended to later.

If you can take care of a rip at once, the canvas will not have begun to curl, and when you place the painting flat, face down, the broken sections will relax into approximate position. If the fabric support is badly frayed and there are loose threads like free-flowing strands of hair, you may trim these away with a pair of nail scissors, but don't trim off any unless they would seriously interfere with the success of your tape repair. When you have done the best you can, press down gently but firmly on all your tapes so that they will stick fast enough to the back of the canvas to keep the breaks together during subsequent transportation. The mend you have made on the reverse is a first-aid measure to prevent further damage —and it will, until you can get the painting to a restorer who will remove your tapes in the course of making a real repair. *Never* put any type of adhesive tape on the face of a painting.

If by any horrid misfortune an entire section of your painting has been cut or ripped out, fit it back into place if possible and use the mending tape just as you would on any other torn section to hold the separated edges together. If that is not feasible, take the torn-out piece and place it first between two sheets of glassine paper and next between two rigid pieces of cardboard and tape the whole tightly so that the piece remains flat and doesn't slip about in its protection before you get it and the painting to a skilled technician. Remember that a canvas painting is so constructed that we cannot reasonably expect its parts to stay stuck together unless they are in plane. Any distortion puts a strain on the structure, with the result that sooner or later some part will go to pieces.

How to Roll a Painting If You Must

It is true that paintings are occasionally rolled. Circumstances may arise when this is the only means of carrying or transporting a

painting, but it is never a wise one. There are times when a painting, because of its size, cannot be transported except in a rolled state. If a painting must be rolled, it should be rolled on a rigid drum of either light wood or very strong fiberboard. The drum cylinder should have the widest possible diameter and be at least several inches longer than the width of the painting. A painting should always be rolled *paint side out*. If you think about it for a moment you can see why. The inner surface of anything rolled is squeezed together; the outer surface is stretched. If you squeeze a painted surface together it has to either wrinkle or chip off. If you stretch it, it cracks. Once the painting is flat again, the cracks—though still present—are minimized to hairlines. If the painted side has been squeezed, when you unroll it you may find overlapping paint films or bare canvas and sweepings of paint and priming layers.

If you must roll a painting (don't, if you can avoid it), place it face down on a piece of glassine paper. Put your rolling cylinder at one edge of the canvas back, curve the edge of the painting up onto the cylinder, and tape the tacking margin to the cylinder so that the painting will not slip about. Then revolve the cylinder slowly so that as the painting rolls onto it the glassine protects the face of the picture from coming into direct contact with the threads of its own fabric reverse (Figure 39). Wrap the roll in waterproof fabric or paper and seal it with tape. If adhesive tape is not available, use the

Fig. 39

broadest flat ribbon you can find. Never use cord to tie up a rolled painting, because when the strings are pulled taut they cut into the packaged picture and leave marks much the way a tight belt does on a linen dress. The fragile nature of a painting on canvas does not change merely because it is out of sight.

How to Keep Paintings Safe When Redecorating Your Home

Once your painting is off the wall it is quite unprotected. Both the front and back are vulnerable. Unless the back has already been

protected with cardboard, you have no idea how much damage can occur. People forget that a painting may be broken from either side, like a piece of window glass.

A depressing number of accidents happen to paintings when rooms are being redecorated. Usually, paintings are taken off the wall and stacked in some "safe" place. A closet seems to be the favorite. If you are going to use a closet, empty it first so that things won't fall down on the paintings, and then *lock* it. Otherwise, your children may decide that their skis, hockey sticks, and skates should also be in safe storage, and Grandma may shove in a lamp as well, or your husband his fishing rods. It is not uncommon for one or even several of these additions to pierce right through the paintings. So if you take down your paintings, the wisest plan is to stack them either in an empty closet that can be locked, or against the wall of an unused room. In either case, stack them with intervening sheets of Masonite or strong cardboard so that both front and back are protected. Otherwise, you run the risk of having the hanging wires from one scratch the face of another, or the screw-eyes on the back of a frame dig into the face of the painting leaning against it, and so on. See to it that the bottoms of the frames are prevented from slipping. You can use pillows for this, or pads of sponge rubber (Figure 40) from a hardware store, as I said before.

Fig. 40

If you must leave a picture on a wall that is going to be painted or in a room where there is any decorating going on, be certain to cover the painting completely with a plastic material. Plastic sheeting or waterproof fabric is best because there is no danger of anything splashing through. Even the most experienced house painter can have a spatter accident, and the paint cloths decorators use to cover furniture are never very clean.

Problems in Transporting Paintings

The best way to have a painting moved is by a specialist, an experienced art mover, but they are few and far between. Those not properly trained can do plenty of damage unintentionally. When you have to transport a painting that has been torn or damaged (and temporarily repaired with mending tape), it is generally safer with the painting kept in its frame. Most frames extend beyond the front plane of a picture so that the frame reduces the likelihood of the painting's surface coming in contact with, and being damaged by, the protective wrappings used during transportation. However, frames come in all classifications. A frame can be more fragile than the painting it frames, it can weigh a ton, it can be much too large, or it can be one that the owner does not want to move. If these problems occur, the best thing is to remove the painting from the frame and to make a strip frame for safe transportation.

How to Make a Strip Frame for Transporting Your Painting

A strip frame is quite simple to make yourself or, if carpentry is beyond you, to have made. Take, for example, an average painting, 30 by 25 inches, on a stretcher 1 inch thick. Get some wood about ½ inch thick and about 2 inches wide. Cut two strips 30 inches long and two more 26 inches long. Centered in each piece of wood, some 4 to 6 inches from the ends, drill holes for screws: two holes—or more if you wish—in each strip of wood. Using ¾- to 1-inch-long wood screws, attach these strips appropriately to the four tacking edges of the painting so that there is a ½-inch overhang at the back and also at the front of the picture. You can have the strips cut from wider stock if you prefer, but ½ inch offers sufficient protection for a painting of average size. The strips are *screwed* in place because they are secured to and will be removed from the wooden stretcher without exposing the painting to shock or strain, they are not apt to work loose, and their firm attachment permits the painting to be picked up (Figure 41) by the strips without the fingers touching either the front or the back surface of the picture. The protection of a strip frame is worth all the trouble it takes to make.

You may package your painting in its strip frame by wrapping the whole unit in glassine, then placing it between two strong pieces of

Fig. 41

cardboard slightly larger than its outer dimensions, and tying the parcel together with string. Pull as tight as you wish, because the pull of the cord is taken against the wooden strips and does not come in contact with any part of the painting. This is a safe way to move unframed canvas paintings with protection for both front and back.

How to Move a Painting in Its Frame

If you decide to move the framed painting in your car or a taxi without taking it out of the frame, certain precautions are advisable. If it is small and the frame not too ornate, wrap it with glassine as just described and then tie it up between two pieces of strong cardboard. This time, however, use pads of thick cloth or wads of corrugated paper (Figure 42) to prevent the strings from cutting in when pulled tight. If you prefer to make use of tough plastic tapes

Fig. 42

to secure the bundle, be extremely careful not to let their adhesive come into contact with the surface of your frame; removal of the tape will also remove the finish from the frame. If the framed painting is too large for you to package conveniently, or if the frame is too ornate, protect the corners with air-seal (bubble-wrap)

plastic or some form of clean cushioning and position it in your car with protective boards front and back. The size of the framed painting and the size of the car will determine where and how the painting should rest, lying flat or standing erect. Whatever you decide, either have someone hold it steady on the journey or do your best to brace it against any sudden jolt.

Once some friends were bringing to our house a group of their paintings carefully stacked in the back of their station wagon. They had no cardboards between the paintings, nor were the paintings protected by solid backings. When they were only one block from where we live, a car ahead of them made a wrong turn without warning. To prevent an accident, the station wagon had to be wrenched to one side. There was a frightful jolt. No one was hurt, but the stacked paintings were jerked out of place and fell one into another. Three of them were pierced through the back by the corners of the next painting.

Another time, a woman who was moving out of town for the summer took her favorite portrait with her in the car. She tied it carefully in place, upright against the back of the front seat, covered with a thick down quilt. On the back seat there were some packages and a small portable radio. She too was forced into an emergency stop. The packages fell onto the floor of the car, but the radio flew forward, smashed smack through the bed quilt, and tore a ghastly hole in Great-Grandmother's face.

This kind of accidental damage need not happen. It isn't that people don't use sense when they transport pictures; it's that they forget the fragile nature of what they are handling: it looks solid but isn't. A canvas painting presents a flat surface front and back, but the surface is defenseless. Maybe it is not as tender as the skin of a balloon, as brittle as a thin piece of ice, or as crushable as a sheet of silver foil, but nonetheless, rigid as it appears, it is only a piece of thin fabric that has been stretched tight and decorated in a very special way, and it should be handled with that in mind.

What to Do When You Ship a Painting

When you have occasion to ship a painting, it is safest to send it in a specially constructed crate, via a common carrier—a trucking or moving company, an airline, a railroad, or even a steamship—insured for the nominal amount allowed by the carrier's customary contract and protected for its full value by a Fine Arts All-Risk policy, which you can obtain from your insurance broker.

Excellent brochures have been published on how to construct a packing case and pack a painting in it. If, however, you are short of time and need a crate made immediately, note these fundamental points.

First of all, no matter what else the carpenter or the packer tells you, have the case made solid. An open-slatted crate lined with waterproof paper is lighter and costs less to make and ship but offers no safeguard against an accident. It is as vulnerable as a medieval knight would be in latticework armor. A solid case may be made of a wooden collar with front and back faces of pressed wood, Masonite, plywood, or any similar type of tough board. If the case is large, the faces should be reinforced with crossbars of wood to preclude sagging.

Until the painting is in it, the crate may be put together by nailing. Once the painting is inside, the last piece that goes on—the one that closes the box—*must* be put on with screws (Figure 43). It takes longer to do and is a bit more of a job than nailing, but it's the only way to attach the lid without the blows of a hammer jarring the

Fig. 43

case and probably damaging the painting. Besides, when it comes to unpacking, think of the hazards presented by nail pullers, claw hammers, and chisels. This way we invite an easy removal of the screws and a lifting off of the top lid, with no danger of boards ripped apart and nails left behind and a minimum of trouble for the unpacker or even the repacker. A final point in favor of the screw-top case, as it is called, is the fact that it can be used over and over again, at a great saving in the long run.

If the securely packed painting is being sent where it will be opened by another person, use crayon or an indelible marker to identify the side that opens, with an appropriate legend. One example might be: "Open this side by removing ten screws." Arrows drawn from the legend to the screwheads will keep them from being missed.

Serious Trouble and Important First Aid

Fire Damage

Some accidents that befall paintings are definitely beyond our control. The worst of these is fire. The regeneration of a fire-damaged picture depends entirely on how badly it was burned. Smoke damage is usually to the surface only and can be removed. Excessive heat is far more serious. Its effect on a canvas painting is the same as on any painted surface: the paint blisters and the support disintegrates. There is almost nothing that can be done to save a painting that has suffered serious fire damage. Slight damages have been repaired, but if the damage is more extensive, the repair is seldom satisfactory and the picture looks like what it is: a preserved ruin.

How Water Damages a Canvas Painting

Accompanying fire is the inevitable hazard of water. Although it is also quite serious, I can give advice for this type of damage. Again, I believe this is an instance in which immediate first aid can retrieve a painting that might otherwise be a total loss.

When the fabric of a canvas painting gets wet, it acts in exactly the opposite way from what is customary in linen cloth—it expands, then shrinks when dry. This difference in behavior comes from the

glue sizing used in the preparation of the fabric as a support for a painting. Sizing swells when wet, and the swelling forces the canvas to expand. This is the reason so many paintings sag loosely on their stretchers in damp weather and tighten up again when humidity drops. When the upper layers of paint are still very fresh, they are flexible enough to expand and contract with these changes in humidity. But once they have dried to comparative inflexibility, they are no longer able to accommodate a change in dimension. The layers can no longer adhere in their original position when such a change occurs. When the shrinkage that follows wetting takes place in the fabric support, there is inevitably too much of the top layers for too little supporting space. If you have ever tried to replace a jigsaw puzzle in a box too small for it, you know just what happens: the sections of the connected puzzle buckle up and then burst out of place.

If you can treat your water-damaged painting while it is still damp and before it has a chance to shrink when drying, you can prevent the picture layers from tenting up and buckling off.

First Aid for Serious Water Damage

In general, the treatment is similar to the one described for taking out dents and bumps, only this time the dampening of the canvas has occurred without control and watchful regulation, and the wet area is apt to be large. Arrange, as instructed before, a flat surface covered with a waxed or water-resistant paper and place the painting face down on top of this. Note that glassine paper is *not* water-resistant. It should *never* be used for this treatment. It wrinkles horribly from even a drop of water, and all its wrinkles would be impressed on the face of your picture. Have a supply of large white blotters big enough, if possible, to cover the whole wetted area, and place one of them next to the canvas to absorb the wetness. In an emergency, if you can't get white blotters use several thicknesses of newspaper; this too will absorb dampness, though less efficiently. On top of the blotter place a large, rigid, flat slab, such as a piece of plate glass or a sheet of smooth Masonite. Cardboard is no good; it reacts unfavorably to moisture. No matter how stiff it may seem, it is not rigid enough to be effective. On top of the flat surface put four or more weights (Figure 44), as many as you can get on, so that there is considerable pressure. Change the blotter or newspaper layer every half hour, as it absorbs the dampness from the canvas; replace it with a dry one. Put back the rigid surface and the weights

Fig. 44

each time. Keep changing the absorbing layer until the canvas feels dry to the touch. Then apply a fresh, dry layer plus the weights for about twelve hours more. Remember that unless you place the rigid slab between the absorbing material and the weights, you apply no overall pressure on the water damage; any section uncontrolled by pressure will shrink as it dries out.

Don't attempt to pick up the painting to examine it until it is thoroughly dry. Even then, be very cautious. There is a possibility that the waxed paper put down to protect the surface will have stuck to the face of the painting. If so, *leave it there!* Make no attempt to remove it. Take the painting to a restorer, who will ease it loose with a mild solvent and gently free it from the varnish without pulling away any part of the picture. As long as the paper is stuck to it, the paint surface will stay in its proper place. If you hadn't put the waxed paper down, the paint might have stuck to your working surface and stayed there when you picked the painting up. When good-quality waxed or kraft paper is used this rarely happens, but in cases of extreme wetness or when the isolating paper has unsuspected weaknesses, this can take place. Do *not* try to pull the paper off, or the paint is likely to come away with it. Let someone who knows how to do it dissolve the adhesion under conditions of full control.

Drying a Painting with Impasto

If the painting that has been damaged by water has any impasto —heavy globs of paint that stick out from the picture plane—slightly different preparations must be made to prevent these ridges of paint from being broken off or crushed under pressure. Cover the flat working space first with a piece of felt or thin wool blanket and put the waxed paper down on top of this cushioning layer, then the painting, face down so that the impasto is protected by the softness of the receiving surface when put under pressure. Be careful not to

62

use a blanket with a textured weave or quilted stitching, since such irregularities would be transferred to the face of your painting during the pressing. It is vital to keep in mind the function of each item used in making a repair so that the desired result can be attained.

What Happens When Water Damage Is Neglected

When water damage has occurred in your absence and the wet canvas has already shrunk together and forced the paint film up and out of place, keep the painting flat, face up, so that any loose paint will not fall off. If you can, get a restorer to come to prepare the painting for being moved safely, by applying a protective facing to it. Unless measures are taken to hold the surface in place during motion, transporting a painting when the paint film is loose (Figure 45) almost guarantees that it will fall off the fabric support. Once off, it is impossible to reconstruct the broken surface even if you

Fig. 45

have saved the little bits of paint. If you can maintain the loosened parts of a picture in their original position and consolidate the structure before any losses take place, there is no need to compensate for any part of the original with new materials.

What It Means to "Face" a Painting

As a rule, not all the surface of a painting is equally weakened; some portions may still be solid. So, if the loosened parts can be kept in their true relationship and anchored to the surrounding firm sections, the whole is given temporary strength. The simplest type of protective facing is thin tissue paper positioned over the broken surface of a picture, then relaxed to conform with it by application of a mild liquid adhesive. The tissue dries to a surprisingly reliable

skin. It provides topside security to keep in place all the disjoined segments of the pictorial design until major operations consolidate the structure from its reverse.

The adhesive with which a facing is attached should always be so mild that as it dries it will never act to pull the loosened parts it covers farther away from their support, and whenever possible it should be foreign to the medium in the layer it protects. For example, you would not be well advised to employ a water-soluble adhesive to attach a facing tissue to a water-soluble film such as gouache or fresh tempera, although the immediate layer, say a varnish, can be less of a determining factor in the selection of a facing adhesive than those of the structure beneath. Short of acute emergency, no skilled restorer applies a protective facing until a thorough examination has revealed the individual characteristics of the damaged painting. Facing a painting is not a repair; it is a temporary expedient to preclude further damage until appropriate treatment can be undertaken. It should hold everything in place the way a first-aid splint does for a broken bone, but the right way, sparing more trouble instead of creating it (who likes to have a broken bone reset?) so that the whole painting can be correctly consolidated from the reverse, at which point the facing is gratefully discarded, the first-aid procedure having served its purpose.

How to Face a Painting

Emergencies rarely occur at places conveniently situated for their correction. If the layers of your painting have lifted so that what is underneath becomes visible and you cannot get experienced assistance, you will have to put on a protective facing yourself. You must not contemplate moving your painting without this safeguard, difficult and touchy as it is to provide. A knowledge of the proper system for application must be viewed as an essential first-aid technique for collectors.

The normal facing for an oil painting is white tissue paper applied with *thin* water-soluble paste. Do *not* use undiluted store paste, however mild its action may appear to you. It is too strong. Get a white scrapbook paste, take a small amount out of the jar, put it in a clean glass, and dilute it slowly with warm tap water. Add a little water at a time, stirring the lumps out until you have a smooth mixture about the consistency of medium cream. To make sure the lumps are out, strain the diluted paste through a piece of cheese-

cloth. You can make as much of this as you want to. It is better to have extra paste to throw away after you have finished the facing than to run short in the midst of your task. Get a reasonably good clean, soft brush, 1 inch or wider—one that will not lose its bristles on the work, which can be very annoying. Get several sheets of unglazed white tissue paper. In a pinch you can use rumpled tissue that has been smoothed out, but flat sheets without creases are much easier to handle.

The painting to be faced should be placed picture side up, with the supporting blocks—or pile of magazines—under the canvas. Cut a piece of the tissue paper to a size larger by a good 2 inches in each dimension than the loosened area you want to protect. Lay the piece of tissue gently in place over the broken-up paint and hold it there lightly with one hand. Dip the brush into the dilute paste mixture and, starting in the middle of your piece of facing tissue, slowly brush the paste onto the top side of the paper. The watery paste will wet the tissue and penetrate it to the loose surface beneath; the tissue will become translucent and cling to the picture. Keep your mind on what you are doing. Gradually saturate the facing tissue, brushing slowly to the outer limits of the paper. Hold the facing tissue in place with your fingertips (Figure 46). Don't let go until you have finished, because the brush can pull the tissue, wet or dry, out of place—disastrously. The paper is likely to wrinkle, but

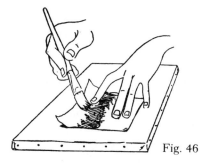

Fig. 46

try to use your fingers to keep the unwetted parts as smooth as you can. Always work from the edge of the wetted area out into the dry, so that you leave no islands of unattached tissue behind. Once wet, the paper can tear easily, so don't go back over what you have done more than you must. If you do tear a hole, leave it alone; you can patch it easily with another tiny piece of facing on top of the hole after the torn one is dried. Try *not* to run the paste over onto the face of the picture where there is no tissue. If this should happen—

and watch out for it—be sure to wipe off gently all traces of free paste. Without the surface layer of paper, paste is a harmful surface deposit.

If you want to practice first to see how it works out, try this method on a piece of glass or any fairly flat surface. You will see that the tissue expands a lot as it gets wet and that the expansion causes wrinkles both in the wetted and in the dry parts. You will also find it difficult to prevent the paper from folding back on itself and sticking together. It is especially hard to avoid tearing it. Until you are experienced, do not try to face too large an area at one time. Limit the size of your tissues to about 6 square inches. If there are many little lifted-up areas in the painting, do a series of small facings with enough distance between them so that there will be no danger of damaging a finished facing when you apply an adjacent one. Wait until these first ones have dried completely; then you can continue with the closer ones, overlapping if you wish, with perfect safety.

Points to Remember about a Protective Facing

As the facing tissue dries out and the water evaporates from the paste mixture, the paper turns white again, shrinks back to its initial dimensions and becomes amazingly strong. You will have to be most careful of the painting until the facing is dry, but once dry the picture can be moved about at will without any risk whatever to the loose paint film. When a facing goes wrong, the usual cause is an improperly mixed paste. If the mixture is too strong, it will pull the loose paint up and away from the canvas. If it is too weak, the tissue may curl free by itself. If you work patiently and carefully there is no reason you can't do a good job. It isn't as though this were something you expect to do over and over again. You are coping with a crisis in the life of your painting and it's best to know what can be done to prevent serious loss.

How a Painting Can Change without Any Apparent Cause

Aging

As mentioned in the discussion of structure, from the moment an artist finishes a painting it begins to age. If it has been well constructed, if the artist has used sound materials and wise methods, the aging changes are not extreme and the painting is unlikely to alter drastically in appearance. On the other hand, totally unsuspected faults may induce a wide variety of alterations that were unobserved during their early developments but, when their blemishes eventually become blatant, are then viewed as sudden and incomprehensible change. Since it would serve no useful purpose in this brief review to include all the anticipated alterations, let alone the peripheral factors that contribute to them, I have arbitrarily selected those alterations that I believe should receive remedial attention from owners and will try to explain why and how these occur in canvas paintings.

Painting materials go through a drying process for, let us say, a period of years or decades. In the beginning, oxygen is absorbed from the air, increasing the weight and bulk of the upper layers. A gradual loss in weight follows the initial increase, and the ensuing shrinkage makes the material sensitive to any encouragement to rupture and pull apart. Unless they catch and hold dirt or happen to be viewed in oblique lighting, small cracks seldom disturb owners. Large-interval cracks can produce such marked surface disfigure-

ment that their unpleasantness rather than the pictorial design is the more noticeable.

As a rule, the changes that you had best take action to correct are the least obvious.

Age Cracks

Although the varnish, paint films, and priming are more or less flexible, they more or less conform to the movement of the fabric support. Once any or all of them lose elasticity, this strain—from expansion and contraction as the canvas absorbs and releases moisture from the environment—is too much; the embrittled portion breaks apart in fissures. The cracks thus formed are deep. Classified as age cracks (Figure 47), they originate from causes outside the limits of the paint layer. They resemble so many very narrow—or

Fig. 47

sometimes widespread—versions of the letter V, with the pointed base touching the fabric support. Cracks tend to start in the priming and split their way up through the paint to the varnish.

Mechanical cracks, a subdivision of age cracks, result from causes outside the canvas painting. I guarantee that, although you may not have realized what they were, you have frequently observed some of their more common forms: (1) the cracks, some 2 to 3 inches in from the rim of a canvas painting, that result from the sagging fabric coming in contact with the sharp inside edge of the stretcher strips; (2) concentric circle patterns, seldom perfect circles but close

enough for the description to fit, that are caused by some pointed pressure that once dented their epicenter; and (3) the crackle that looks like the large tailfeather of a bird and is caused by a few seconds of slippage contact with the corner of a chair or table, or the glancing blow from a hammer head carelessly driving keys into a stretcher. All of these, and other forms of age cracks that show up in the surface of a painting, are the direct result of unnoticed strains or forgotten contacts, and all have broken the structure but not the canvas supporting it.

Drying Cracks

The appearance of drying cracks (Figure 48) is invariably upsetting. Drying cracks originate in the paint layer. Caused by some form of constructional impropriety, drying cracks hardly ever expose the canvas support, scarcely ever the priming, but may almost always reveal subportions of their own layer or of a lower

Fig. 48

paint layer that may or may not relate to the visible pictorial design. Described by such terms as *orange peel, alligatoring, widebranched,* and *islanding,* they are distinctly unpleasant. The space between one and the other side of a drying crack can be as wide as $\frac{1}{2}$ inch; the color exposed in the opening may be similar to or contrast with that of the surrounding surface.

Many owners feel that seriously distracting drying cracks should

be filled and inpainted to restore pictorial unity. Opinions are divided. Some art scholars agree that as long as drying cracks are skillfully inpainted by an ethical practitioner who limits compensation exactly to the fill and covers no original surface on either edge of it, this restoration is permissible. Other scholars are convinced that, no matter how refined the execution, inpainting cracks adds to the picture the work of a hand other than that of the original artist and should never be permitted. There is no question but that inpainting of rip crackle does slightly alter a design. However, the very movement of the contracting or expanding paint (expansion takes the form of wrinkles or overlap) has by itself shifted forms and colors away from their original positions. Whatever the decision, change exists in such a painting whether or not attempts are made to render it less obvious.

Cleavage

Drying cracks look much worse than age cracks, but the steps you may take to correct them are far less urgent than the need to deter development of the deep breaks in your painting's structure. Age cracks in a canvas painting are a way station on its path to disintegration. Worry about a painting if its surface looks like a dried-up mud flat or if the edges of paint along either side of a crack are curling. Check the reverse of the canvas. If the concave disruption on the surface is reflected with quilting, convex puckering of the fabric support, the next expansion-contraction cycle will cost the loss of pictorial layers. With the inevitable persistent movement, age cracks progress by shifting, buckling, and cleavage (Figure 49) of the upper layers to flaking away of the little broken-apart layered

Fig. 49

Fig. 50

sections. Voids may already have occurred on your canvas painting (Figure 50) and gone unnoticed. When these are small and veiled over with dirt, no one sees them for what they are.

Cleavage is a predictable progression from age cracking. A canvas

painting with a web of age cracks, irrespective of how fine, is ultra-vulnerable. If it is physically possible, hold your canvas painting up in front of a good light—sunlight from a window, or an electric bulb—but not too close to it. If you can see through the cracks to the threads of the canvas, I doubt that you need further confirmation regarding the perils of this state. In this condition any undue pressure is likely to result in loss of surface. It may take years, but I once saw startling proof that even the mildest indentation makes a fatal impression on an old canvas painting. I examined an early American portrait with a number inscribed on its canvas reverse in chalk. Exactly opposite this on the face of the painting, paint and ground had flaked away in identical numerical form. Admittedly, I could not know when within the past 150 to 200 years the number had been chalked on; that it had directly caused the flaking of the surface, however, was irrefutable. If you can, have age cracks reconsolidated before they develop into cleavage; but whatever the stage at which you discover symptoms of structural separations, get treatment for the painting as soon as you can.

Bad Materials and Malpractice

Through ignorance or misinformation, artists occasionally combine substances that are chemically unstable or incompatible. All too often, for reasons of cost or impatience they proceed unwisely in composing a painting: some have been known to paint as many as seven pictures, one on top of the other. A few have been known to shift from one medium to another within the same paint layer. Such practices lock into a painting what the insurance companies call inherent vice, predictable self-destruction; you cannot insure against it. Drying crackle is the least complex form of inherent vice; too many of the other kinds lie deep within a structure, beyond easy reach from either the back or the front. From an owner's point of view, inherent vice remains unrecognized until it erupts on the surface in some form. As with other diseases, diagnosis of the cause is often forthcoming after the evidence is evaluated.

In the nineteenth century artists delighted in the newly manufactured paints containing asphaltum and bitumen. These paints had fine application qualities, but once in place on a canvas they rarely stayed there. They never seemed to dry. Even now, after a century, in warm weather they will run down a surface. I know of a picture in which the bituminous paint has oozed beyond the bottom member of its stretcher to dribble out over the molding of its frame.

Blakelock, Ryder, and their contemporaries used prepared paints formulated with these nondrying substances. There is a story, probably apocryphal, told about Blakelock that a client returned one of his paintings because the picture had all run down to its bottom edge. Blakelock is supposed to have turned the picture upside down and left it that way until the paint ran back into place again—at which point he gave it back to its owner. I have seriously advised owners of certain beautiful Ryders that I have treated either to display them lying flat or to arrange to reverse their hanging position during the night hours. Many paintings of this period exhibit cold flow: their picture planes are crisscrossed with wide-interval rip crackle spotted with islands of shriveled paint, the whole scene obscured to near-meaningless crust floating on a film that will never, never dry. The causes combine structural incompatibility, bad materials, and the malpractice of painting wet to wet.

Today there are also materials offered for an artist's use that may lead paintings to self-destruct through no fault of the artist, and there are artists guilty of malpractice who claim indifference to the survival of their creative efforts. They like to experiment. A few make tests on the substances they employ but seldom wait long enough for positive conclusions as to durability. When disaster strikes, some who have boasted indifference angrily demand that restorers save the spoiling fruits of their genius.

Sometimes, when a painting "suddenly" begins to fall to pieces, the reason may be that its previous restoration treatment has worn out or was perhaps inept. Like other forms of deterioration, this is usually a gradual development without clear signposts denoting the progressive stages unless these are explicitly sought. Reasons for some of these alterations will be explained in the next chapter. Keep in mind that no painting changes without cause, but too often the cause is realized only after its effect has reached unfortunate proportions.

CHAPTER EIGHT

What Happens When a Painting Is Restored

When taking a painting to a restorer, how can you be sure the work will be done right? How can you be sure that the restorer is a good one, or that the methods used on the painting will be the wisest, best, and most lasting of all those known? As a matter of fact, you cannot be sure of any of these things, but there are certain safeguards that help. There is so much that a really expert restorer should know and be able to do that there are in the world only a few practitioners who actually fulfill all the requirements. Quite a number, however, are first-class restorers who do a magnificent job of conserving our vast heritage of art.

What Constitutes a Good Restorer

A restorer acquires skill and ability through study and practical experience. There are in the United States several graduate schools teaching this expertise, but their teaching is not uniform, nor are their graduates equally gifted. Formal education is a step in the right direction, though. When conservation of historic and artistic works becomes a regulated profession like medicine or dentistry or law, there will be a common enforced background and required examinations at state level leading to a license in the field. This will no more ensure optimum intelligence and capability from every certified operator than regulation ensures top competence for all

73

members of the already licensed professions. Still, it would protect the public from the totally unskilled and should guarantee some standard of performance.

No matter what category—sculpture, painting, designs on paper, books, decorative objects, archaeological, ethnographic—becomes the special field of expertise, a conservator must study the history of art, the materials that have been used through the centuries to create it, and the structure and behavior of these materials and should be familiar with the scientific means for examining, restoring, and preserving art forms. Whatever the selected field of treatment, a restorer must understand basic chemistry and physics and be able to interpret, if not take, condition photographs, infrared photographs, ultraviolet photographs, and radiographs. Manual dexterity is essential, and ability to paint is assumed as part of this necessity. In the past this particular ability was accorded far too much importance, and the work of restoring was too often relegated to artists who needed additional income. A frustrated or unsuccessful artist rarely makes a first-rate restorer; the very ability to create artistically prevents him from giving proper objective respect to the artifact he treats. He is always tempted to improve or alter, secure in the conviction that what he does will be just as good as, if not better than, the work of its original creator. That is fatal. Humility before the object to be treated is an elementary characteristic of a good restorer.

Danger Signals in a Restorer

Every treatment that has been developed and tested in the field of art conservation, as in almost all scientific professions, has been published and is available for further study, experimentation, and use by any practitioner in the field. There are no mysteries; no trade secrets remain that have any validity. Exquisiteness of performance, as in surgery, is a gift belonging to the individual. This and the degree of sensitivity are private possessions. The method to be used in the treatment of a painting is common knowledge. For this reason if for no other, it is wise to shun restorers who decline to tell you what they propose to do and insist that their operations are secret, the telling of which would endanger their income. Good practitioners have no need for such pretense to special endowment, for they prosper according to the excellence of their work.

How to Select a Restorer

A client has every justification for asking in advance what is going to be done to his painting. Rightly or wrongly, what is proposed may not seem sound, and the owner may decide to have someone else suggest another type of treatment. Shopping around in restoration often becomes a silly habit and an abuse of valuable time, but it is a prerogative that should not be denied. When one is ignorant of a field it is best to get reliable advice and abide by it. Most museums, when asked, will offer a list of restorers in various categories of work and state definitely that they are partial to none. These will be names of reputable practitioners, but the choice among them is entirely the responsibility of the inquirer. Annoying as it may seem, this is only right. Museums try to serve their public, but they must take care to protect themselves. They are not advertising agents and should not be expected to be answerable for the quality of work done outside their premises. The list of names they offer is a convenience and a courtesy to the public, but never a warranty.

What to Expect from Your Restorer

When you select a restorer from the list of names, get in touch with him and ask if he can come see the painting or if you may bring it to him for an examination of its condition. Before you write or telephone, have all the facts about the painting at hand: its approximate date of origin, the name of the artist if you know it, its dimensions, and some description of what seems to be wrong with it. Once the contact has been made and the restorer has examined your painting, you may request a report on its condition, a proposal for its treatment, and an estimate of costs involved. I cannot predict whether or not the specialist you choose will charge for examination time and travel involved, if any; find out ahead of time. It is fairly common for the treatment proposal to include suggestions for two or more remedial systems. These may be major or minor types of preservation, long-lasting or temporary expedients, with commensurate differences in cost. Which of the proposals you find acceptable may rest on the value of the painting to you or on your immediate or future plans concerning it. If circumstances permit, carry out the proposed plan of action that will best preserve the painting. Most

people do not fully understand just what enters into the process of conservation of works of art. Let me explain the basic procedures in examination and treatment in a brief account of activities to which some of us have devoted most of our adult lives.

Examination of a Painting

Examining a painting is an exciting experience. It is an effort to find out and record as much pertinent data about the painting as possible before any work is undertaken. The study is visual, photographic, and analytical; the phases run into one another. Some of the information gathered is positive, some negative, and some proves disappointingly irrelevant. We have no machine into which we can thrust a painting and have it come out the other end with all the answers tabulated. Even the most sophisticated instrumentation we have remains vulnerable to human misjudgment. We do the best we can and strive for steady improvement, but there are plenty of times when no two consultants reach the same conclusions.

Sometimes unique physical factors in the construction of a painting interfere with diagnosis. Additions from previous restorations— linings, cradles, thick layers of adhesives like white lead, extensive repaints obscured by brown varnish—can blur all evidence concerning the actual state of an original. It is not uncommon that, after examination, during stages in a remedial treatment, the real explanation for certain confusions comes to light. When treatment is not undertaken, there are times when definite answers cannot be anticipated in a seemingly contradictory situation.

The Importance of Photography

No painting of any merit should ever be worked on until a photograph of its entire surface has been recorded in normal light. Few of us can recall accurately what a picture looked like before treatment changed it in any way, and photographs perpetuate observations made at a given time. They can be studied, be shared, and serve as documentation for the future. Detailed photographs of special problems such as acute lifting up of a painted section, wide-interval crackle, scratches, or punctures—all the evidences of condition— should be thoroughly recorded in whatever lighting serves to emphasize their development. Surface textures and irregularities of

picture plane are best illustrated if photographed in oblique or "raking" light. Condition photography is worth every penny it costs. One rarely takes too many photographs of a painting before treatment.

What Ultraviolet Can Show

Most old paintings have been restored at least once and the work was undertaken for a reason—something went wrong and had to be fixed. Discovering the extent of earlier restorations helps to decide how much, if any, work needs to be replaced. Ultraviolet rays excite differing fluorescence in various materials found in a painting. The purple color of the filter is also reflected from certain substances; the pattern of tonal and color variations these rays and their purple accompaniment produce have recognizable interpretations. In the study of ultraviolet there are more exceptions in recorded responses than there are rules. To generalize, however, varnish (as a rule!) fluoresces yellowish green; shellac fluoresces orange; areas of repaint, when not covered by too dense a varnish layer, make themselves obvious in a dark purplish reflectance; areas devoid of varnish but covered by dirt resemble these last without the admixed coloring of the veil of greenish yellow, and so forth. If a repair has been recently overpainted and the original painting is comparatively old, the difference between these parts under ultraviolet is startling, all the more because, in normal illumination, where one ends and the other begins may be totally invisible. A photographic record of any remarkable condition observed in a painting under ultraviolet rays may be made with ordinary black-and-white or color film. The exposure, which is long and tricky, should be delegated to an experienced technician.

There is no doubt that the contrasts that may occur between old and recent portions in a painting, as they suddenly proclaim themselves under ultraviolet scan, invariably influence a collector to further investigation into the physical state of his possession. An urge of this type is not always conducive to the comfort of a dealer. I must report that an "ultraviolet-resistant varnish" has been perfected and finds its way to the surface of quite a few pictures offered for sale. I trust you will remember that ultraviolet tells us only part of a story when it tells us anything, and that there were seven keys to Baldpate.

Infrared Examination

The infrared band on the electromagnetic spectrum is also used in the examination of paintings. Infrared viewers have been marketed that resemble miniature television units, with which one can presumably discover whether or not these rays reveal special information about a painting. Since the images in the viewer are somewhat fleeting and only one person can use the gadget at a time, any alteration in surface appearance activated by infrared is advisedly recorded photographically on infrared-sensitized film. Infrared penetrates varnish and certain dark colors to accentuate outlines of forms that are usually invisible in normal light. It does not penetrate all varnishes or all dark colors but has been used successfully under selective conditions to disclose subsurface inscriptions, repainted signatures, artist's changes, and, very occasionally, previous damage and repairs. Infrared is unpredictable, but if we have any inkling that it could add to our knowledge, we take the photograph because a study of the print can disclose details in the subsurface layers of a painting missed during the short-term observation of these on the infrared viewer. Infrared can be recorded only on its special film, and the photographs, though less complex than ultraviolet ones, had best be assigned to a good technician.

X-ray

X-rays, the most publicized form of scientific examination of paintings as well as one of the very oldest, are often quite misunderstood. When X-raying is used to register the densities in parts of our bodies, the interpretation is based on the comparison between anticipated knowns and existing anomalies. When a painting is X-rayed we also register its densities, but since the percentage of unknowns far exceeds the knowns, interpretation becomes a bit like unraveling the parts in a double-exposure photograph. X-rays record the density variations in the entire structure from front to back, with no allocation of gradations to any specific layer. To make the interpretation even more complicated, though tonal differences in a radiograph are not necessarily opposite those in a black-and-white photograph of a painting (white lead, since it is dense, is always white on X-ray film), where they do reflect the variations of surface tones the reflection is based on how penetrable the material proves

and not on its color. A radiograph is best "read" in conjunction with the actual painting. Be patient; there are many confusions to surmount. Place the film against a good illuminator and take your time getting acquainted with it.

X-rays register on specially sensitized film. The largest is 14 by 17 inches. It takes many of these and assorted overlaps to document a large painting. The film must be in direct contact with the part to be X-rayed. The developed film is referred to as a radiograph, which may in turn be photographed and a print made from that negative. The clarity of the recorded penetrations depends on the kind of instrument used, on the particular selection of X-ray film involved, and very much on the competence of the operator to judge exposures appropriate to the structure of the painting. Techniques of radiography are so highly developed that any artistic structure that can be brought into the requisite contact can be X-rayed, from paper to stone and fabric to metal.

Within canvas paintings, a radiograph may show the characteristics of a concealed image, a painter's change in the positioning of a head, a change in accessories preferred by a sitter, the removal of a tree, or a form from a landscape. It will not tell whether these were altered by the hand of the initial artist or by a restorer. It may show the extent of hidden damage, of fillings surrounding it, and indicate their nature—at least whether the substances used were dense or soft. It will almost always show how many uses an artist, or several artists, have made of a single support. A radiograph is *not* likely to reveal hidden signatures or dates. Inscriptions are generally applied with dark colors in thin mediums; to offer resistance to X-rays they would need to be applied in dense materials such as red or white lead paint. This is possible, but in truly rare instances.

Radiographs require interpretation. The evidence radiographs indicate should never be deemed infallible. It isn't that science makes mistakes; it is that explanations can be incorrect. I was once involved in a famous case in which a masterpiece was rejected by a buyer as extensively repainted because in the radiograph a large area of white lead occupied the same space as did an important face. My husband made a thorough examination of this section of surface under high-power magnification. It was his opinion that the white lead had to exist on the reverse of the original canvas, as he found the paint layer undamaged. The painting was lined, but subsequently, when the lining was removed, the lead blotch proved to be no more than an artist's smear on the back of his canvas and it in no way concealed any damage. I recount this episode to

emphasize how difficult it is to assign discoveries by X-ray to the correct stratum, and also to point out that not every examination proves a painting is in worse condition than it appears to be!

The Binocular Microscope

I can never understand why some people resist looking through a microscope. Perhaps they fear they will not be able to focus the instrument and will have to admit they do not see what they are supposed to. The binocular microscope is an introduction to a hidden world. Ask your restorer to make sure the area he wants you to view is correctly lighted and in focus, then have him show you which knob helps you change the focus to whatever slight adjustment is needed for your eyesight. Don't give up until you can see whatever has been described to you; it is well worth the trouble and patience. The sureness of a fluid outline, the lacework of minute brushstrokes, the incredible delicacy of a crest of paint—all these qualities and countless more are most fully appreciated under magnification. Beyond doubt, under ultraviolet the contrasts between old and recently applied paint can be dramatic; but nothing, in my opinion, is more revealing to an owner than the study of his painting under a binocular microscope. As you peer down through the age cracks, all the structural layers we have discussed come to sight. If ultraviolet has located repaints in a signature area and infrared has added the information that there are reinforcing strokes, you may be able to see for yourself under magnification the way the new paint fills cracks in the original inscription. The use of the microscope can confirm or contradict (as in the case of the smear of white lead) evidence offered by other phases of an examination.

What pleases me most is that when you, as an owner of a cleaving canvas painting, see this condition under magnification, there is no further need to explain priorities of treatment. Once you have viewed how the broken edges of barely secured parts of a surface seem about to heave in enlargement, like a static moment before an earthquake, you will be in terror for the survival of your picture. No restorer has to argue that consolidation must precede any attempt to clean. No owner would question that even the gentlest swabbing motion might entail loss of those fragile tips of pictorial design. I find myself impatient with colleagues who scornfully reject technical aids as unnecessary adjuncts for those who possess "magic" eyes. The intuitive reaction of an expert restorer to a painting under

80

examination is a remarkable attribute. However, failure to augment this blessing with the extensive benefits to be derived from appropriate instrumentation does seem to me like cutting off one's own nose to spite one's face.

Analyses of Materials in a Painting

Materials in a painting may be analyzed and often clearly identified. The great advantage of this information is that under hazardous conditions, knowing the exact nature of substances can determine what may or may not be undertaken safely to preserve or restore a masterpiece. The better-known methods of analysis are chemical and microchemical, but a range of elaborate instrumentation, used in other forms of research, is also applicable to the investigation of painting materials. This type of examination is not routine. It might be a final resort when procedures for the care of a valuable painting are in doubt or when a painting of importance is under consideration for purchase. We know fairly accurately when certain pigments were invented and even when certain mediums came into artistic use. If, for example, a pigment not discovered until 1703 turns up in the paint film of a picture purportedly executed in the 1500s, we may suspect at least overpaint, if not forgery. The identification of cross sections and specific substances in a painting can run into four figures in cost. I must emphasize that even this information, expensive as it may be, with few exceptions requires interpretation.

Value of a Technical Examination

Under normal circumstances the pretreatment examination of a painting is limited by the equipment housed in a restorer's place or easily available for his use. This is likely to include ultraviolet, infrared, radiography, magnification, and basic chemical testing. Where costly equipment is requisite, the majority of us must forward the specimen to other laboratories for specially designed methods of identification. If this is suggested to you, make sure the information is essential for you to make whatever decision presumably depends on it, or you will find yourself treading a costly path. Whenever elaborate preliminary examination is advised, get an estimate for its costs in advance and find out whether this has been included in your initial estimate for proposed treatment or will

appear as an extra. Most costly examinations are not necessary unless unique problems exist.

Preservation of a Painting on Canvas Usually Involves Lining

The main reason you are interested in taking care of your painting is to make it last longer. Treatment that makes a canvas painting last longer is called preservation, as differentiated from restoration, which can refer merely to the improvement of surface appearance. Preservation covers the operations that stop a painting from going to pieces but by themselves do not necessarily improve its visual appearance. When a painting has a hole in its canvas, the threads are *not* rewoven. When there is a tear in the fabric, the broken sections are *not* just rejoined. When the surface films start to lift and curl away from their support, the picture is *not* automatically taken off the old canvas and put onto a new one. These are all misconceptions of treatment. The mainstay of preservation for canvas paintings, and an ancient method of repair, is lining. The term *lining* is used in the sense of adding or placing a piece of material inside another to give it strength and protection. When a damaged or desiccated canvas is lined, a new piece of fabric is stuck to the back of the original with an adhesive so that there are two canvases behind the paint film and priming, the original weak one and a new strong one. Lining is a physical repair to the body of a painting. The practice has gone on since canvas pictures first became popular. Materials and methods used have altered with time and place, but the fundamental concept of lining is unchanged.

How to Tell If Your Painting Has Already Been Lined

It is not always easy to tell whether a painting has been lined just by looking at it. Many linings made with water-soluble adhesives have cloth or paper tapes applied to the edges of their stretchers, slightly overlapping the front rim of the painting. Scrape away a bit of the tape near an edge and see if there are two layers of fabric (Figure 51). The presence of two canvases at the tacking edge almost always means that the painting has been lined, or if not fully lined, then strip lined, on one or more of its edges. Most canvas paintings

Fig. 51

of any age have passed through the hands of at least one restorer. Given an environment conducive to reasonable stability, most linings should last a good fifty to seventy-five years before they cease to hold together what they were intended to. But paintings, like people, differ, and what works well for one does not always work equally well or equally long for another. You may have a lined painting in good state, or you may find that the lining has become ineffective. Care, as well as climate, has a lot to do with longevity.

Difference between Lining and Transferring

Owners who examine the reverse of a recently restored painting occasionally complain that their genuinely old painting has been put onto a brand-new canvas. In a sense it has, but quite properly so. The old canvas has been concealed by the new reinforcement but has not been replaced by it. In a lining the relationship between all the original layers is unchanged; the layers have just been augmented by an additional support.

Transfer is a term used to describe removal of the upper layers of priming and paint film from an old to a new support. This too is an ancient process, supposedly invented by a Frenchman named Picault who restored paintings in the seventeenth century. We also have records of transfers made in France under Napoleon's orders to preserve the masterpieces he had liberated from Italy.

In the past, restorers had little hesitation about using drastic methods, with the result that not infrequently the operation was a success, although the painting survived in a state rather different from its original one. In the twentieth century, transfer is an excep-

tional treatment for a canvas painting. We have the advantages of technical aids during a preliminary examination to guide us to a more cautious decision. None of us willingly exposes a painting to undue strain or unwarranted risks.

Occasions when a canvas painting might be transferred are those in which the fabric support exhibits signs of decay, structural vice appears to lie in a layer of primings, or when the painting is destined for exhibition or housing in a climate of extreme fluctuations in relative humidity, or when a support of inert material will provide the optimum security. The procedure is not dissimilar to what has already been described. With transfer the greatest effort is directed toward thoroughly reliable facings.

The surface of the picture may be covered first with tissues of paper, then tissues of silk, applied with adhesives selected to best accommodate the qualities of the paint and its textures. These facings are likely to be embedded in molten wax and the whole placed face down on multilayered fine cardboard and made to stick to it by heat and pressure. Only after tests show that the paint is under secure control is the fabric support removed from the reverse. Usually, the existence of the glue sizing—between the fabric and the priming layers—facilitates a gentle stripping away of slightly dampened sections of the support, one at a time. Less felicitous structures demand dry removals, and some circumstances (such as a backing layer of white lead) can cause labors of endless time and considerable personal hazard to the operator, who is protected by an aspirator mask. Once the fabric support has been removed, the exposed priming may or may not be left in place, depending on its solidity as a supporting layer. In all instances, a new layering of reverse supports is slowly re-created and made fast to the old with compatible materials. When there is every reason to believe the painting has been completely reconsolidated from the reverse, the whole is turned over, the cardboard peeled away, the wax bed dissolved, the facing tissues rinsed off one by one, and the front of the picture brought back into view. A successful transfer is a joy for everyone, not to mention the painting: the stages in its painstaking progress are grueling.

Qualities of Lining Adhesives

From the middle of the nineteenth century on, wax linings have been in use, generally in parts of the world, as in the Netherlands, where climatic conditions made this moisture-resistant type of adhe-

sion practical. The majority of restorers were, however, brought up to use glues and glue-paste mixtures. Like all craftsmen, practitioners in the lining of paintings cling to familiar materials and systems in which they have had experience. Not all of us could foretell the effects of the materials and methods we chose to employ. It took a while, and no few misfortunes, before restorers developed the skill and intelligence to select from the range of possibilities the lining adhesive and lining methods best suited to the individual quality of the painting at hand.

Curiously, conditions that were environmentally disparate, between drafty palace museums of Europe and the newly constructed cultural institutions in our country, have approached a common norm, with common woes. As artificially induced temperatures for both winter and summer were installed in exhibition galleries here and abroad and adjusted for the comfort of the visitors, the acute nightly shifts in relative humidity served to accelerate the deterioration of all hygroscopic materials. It took quite some time for administrators to recognize that environmental adjustments for human comfort were not coincidental with the survival of collections. Situations where direct cause and effect could be unhappily confirmed served to direct attention toward maintenance of a more uniform environment and toward employing curative materials calculated to preclude extreme reaction to changes in relative humidity. In the case of canvas paintings, this has increased the use of thermoplastic lining adhesives in preference to those with aqueous characteristics.

In the past quarter of the twentieth century, painting restorers have had such an array of possible lining adhesives and systems for their attachment that it would seem inexcusable to select an aesthetically inappropriate bonding agent or to apply an aesthetically damaging lining method. I would not be inclined to have my painting lined by a restorer who limits his linings to one adhesive and one system for all. I would also not be over-impressed by gadgetry. Vacuum hot tables and suction cold tables can assist in the performance of superb treatments, but fine linings were accomplished decades before any of this equipment was invented. After an ethical restorer has examined your painting, if he discovers any idiosyncrasies that might benefit from an equally unique style of lining, he will tell you whether he feels competent to perform this special technique, or he will direct you to the colleague most expert in this specialty. Ask that everything be explained to you. You decide what is best for the painting; if it cannot be explained to your satisfaction, be cautious in deciding.

Difference between Lining and Relining

Lining and *relining* are terms that have been used interchangeably, with much unnecessary confusion. I am glad to note that the tendency is falling out of favor. Relining obviously means doing over a former lining, a similar but longer and more complicated process than the initial treatment. Nothing lasts forever. A previous lining may simply have worn out or its adhesive ceased to function properly. It might have been inexpertly performed and be affecting the original painting adversely, or the lined painting can have suffered an accident that damaged both its supports. There are no special operational problems in relining so long as the adhesives used by a previous restorer are reversible. The front of the painting is carefully secured while the old lining is stripped away from the back of the original support. The protection of the picture surface for a relining is like that described in a transfer but with, as a rule, fewer layers. Irreversible adhesives, such as lead white and permanent cements, can be removed only with serious risk to the painting. Wax linings, linings with glues and glue-pastes, nonpenetrating linings made with synthetic adhesives—all may be replaced as the need arises. As long as the assignment for removal of an outworn lining and its residue of former adhesive is *not* given to unskilled hands, there is minimal risk. But the cost of irresponsibility or carelessness during this operation can be outrageous. Do a bit of detective work; see if you can find out who *really* takes off old linings before you leave your painting anywhere for that treatment.

When linings are removed from old paintings, inscriptions, signatures, dates, and stencils advertising linen manufacturers or artists' suppliers are often uncovered on the backs of the original supports. Unseen and unsuspected for years, this information often provides valuable historical documentation as well as amusing sidelights on a painting's history. The data should always be photographed; this is one instance when the use of infrared film will serve to record a blurred legend with surprisingly precise clarity. If the discovered legend is located under a stretcher bar it will still remain so concealed, but with inscriptions in more viewable locations a lining fabric of fiberglass or any synthetic material that becomes transparent in conjunction with compatible thermoplastic adhesives will keep the information nicely visible after the lining. Always request a photograph of the uncovered data and, where it would be practical, see if the lining can be kept transparent.

Patching a Damaged Canvas

If the damage to a canvas painting is small and cost or time a consideration, it may be repaired by attaching a patch to the ruptured section instead of lining the whole. Not unlike the first-aid repair you can make yourself with a piece of masking tape, the patch precludes any additional deterioration. The damage is carefully repaired and the only curtailment is in the extent of the added support. Your restorer will mention the possibility of patching; he is also likely to advise against it. This is not because the patch costs less than lining, but because, no matter how expertly applied, its outlines will inevitably become noticeable on the front of the painting in a slightly protruding pattern exactly corresponding to the form of the additional material on the back. Aside from this visual annoyance, patching is an excellent expedient when, for one reason or another, the major treatment of lining is better postponed. When the patch has been attached with a reversible adhesive, its subsequent removal presents no grave difficulty during a lining. The area patched will require a facing to ensure protection for the damaged section during the removal of the patch and its adhesive. The operation is comparable to a small-sized relining—which is about what it amounts to.

Solid Mounts for Canvas Paintings

Some canvas paintings, either because of extensive ruptures or complexities of structure, or because they are destined for housing in climatic extremes or for exhausting travel exhibitions, are wisely attached to rigid supports. Performed carefully, such a treatment does *not* affect their surface texture, *nor* can it even be suspected from looking at the picture plane. Solid mounts are available in many forms. The selection of the most appropriate should be influenced by the reason for its use. Mounts for paintings that must endure the shocks and strains of travel should be kept as light in weight as will be compatible with rigidity. Excellent for this purpose are the solid mounts of aluminum Hexcel core faced with aluminum sheet. Other types have cores of balsa blocks, paper honeycomb, or other inert fillers between faces of birch veneer, Masonite, or even four-ply all-rag matboard.

There are strong differences of opinion regarding the propriety of

87

mounting canvas paintings on solid supports. I do not object to the use of rigid supports when circumstances make these advisable, but I do urge that you request your restorer, should he convince you that such an addition is called for, to line the painting first and then attach it to the solid support.

There is no question that paintings to be exposed to the unpublicized wear and tear of diplomatic hegiras may be spared a great deal of damage when they have been secured to solid mounts. However, even paintings so protected have been known to suffer such severe blows and cuts on their design sides that the face of their mounts is likewise destroyed. When this happens, the painting must be removed from the solid support for repair. This removal, this separation of a fragile original from a fractured solid surface, is reasonably safe when a strong new lining layer exists between the two. Without this intervening, reasonably intact laminate, there are grave additional risks in freeing the painting. Aside from accident, all materials have to be replaced, and plans for accomplishing the renewals should involve the least foreseeable strains.

Revelation

Revelation, in restoring a painting, is the showy part. In this phase of treatment the obscuring films of dirt, discolored varnish, and old repaint are removed from the original. This is the before-and-after part that can be so startling. Muddy greens are revealed as sky blues; grimy yellows turn into crisp whites; brown soup backgrounds come away to show verdant landscape. It can be very dramatic.

I am constantly asked what we use to clean paintings. The answer is that it depends on the painting. It is not uncommon for a series of solvent mixtures to be employed during the cleaning of a single painting. Colors used by an artist have varying sensitivities, some being firmly bonded in their medium and others susceptible to being easily dislodged. The term used to describe the latter is vivid: we say that such and such a color "bleeds easily." There are paintings on which dirtied upper films have to be removed or diminished by fine instruments or with delicate forms of dry abrasion. I once cleaned an entire Gauguin with surgeon's scalpels under binocular magnification. Another time, the only way I could safely clean an O'Keeffe abstraction was by rubbing off the oil varnish cover by means of particles of dry damar resin rotated over the darkened surface by my fingertips. There can be no all-purpose recipes. Your restorer will do the best job he can without risk to your painting.

All of us check and recheck our progress with the microscope and ultraviolet light. When it is not clear whether an area of repaint

might have been applied by the original artist or by a restorer, the owner or the curator has the deciding opinion. It is always wiser to err on the side of timidity; decisive evidence may turn up and removal be effected at a later date. Repaints that are so tough that their removal might endanger the surrounding original are customarily left in place.

Unquestionably, cleaning and how it is professionally performed are of prime interest to collectors. But cleaning has seldom been known to prolong the life of a painting, and the surface of your picture is only the visible top of all those layers it covers. It may rest on top tentatively, not unlike a golf green over a part of the San Andreas Fault. The contrast between a dirty and a clean portrait or landscape may be breathtaking and surely more dramatic than any form of consolidation—except perhaps the return of a sadly broken or torn surface to its picture plane. But please, in your enjoyment of cleaning, don't neglect to check for necessary attentions to your painting, which may be a good deal more than skin deep.

Condition of a Painting Stripped Down

When the decision has been reached that no further cleaning should be carried out, the painting is in what we call its stripped-down state. What is really extant of the original, along with whatever additions are viewed as unsafe to remove from it, will serve as the base, the actual remains on top of which (at your discretion) "makeup" will be applied to minimize what may have been lost or damaged. After all the voids, where loss has occurred below the picture plane, have been properly filled to the correct level—usually with a chalk-gelatin putty known as gesso—a photograph should be taken. Never, no matter how else you may compromise, fail to demand a photograph of your painting in its stripped-down state. It may not be a photograph of great popularity with dealers or one that museums are proud to display next to a smoothly restored wreck, but it is irrefutable documentation for scholars and appraisers. Make sure it is dated. It represents a stage in the life story of your painting.

Compensation

The replacement of lost parts of a pictorial surface is called compensation. It has many styles suited to different situations, intents, and tastes. In the best practice, the stripped-down painting is lightly varnished to provide clear-cut physical separation between extant remains and what will be added to them. Also in the best practice, repainting is limited to retouching or inpainting voids,

keeping additions to the exact limits of what is missing. Original paint should never be covered by accident. The use of careless hands for this work is not excusable, nor is the attitude that would improve the "badness" of an original form. There are occasions when the decision to glaze over, or "pull together," an acutely abraded or sorely disrupted surface appears wise to both restorer and owner. Overpainting, which this is, should be executed with an easily soluble medium, permitting its removal in the future by anyone who wishes, without inflicting the slightest risk to the damaged original beneath.

The proliferation of synthetic resins in this era supplies the restorer with a wide selection of mediums for use with dry pigments. We can make up any color we need in whatever vehicle will be best to employ on a particular painting. The synthetic resins darken little and remain in general easily removable by the same vehicles used to apply them. Limited in special characteristics when they first appeared on the market, these synthetics are now so richly varied that in each category there are several choices. We can use them to create flat or shiny finishes and transparent, opaque, stiff, thick, flat, or thin layers of paint. The only problem is to be careful that our choice is utterly compatible with the particular paint film it may join in compensation.

One misconception regarding compensation concerns the duplication of original materials. We do *not* try for this. We do not attempt to locate a terra verde exactly like the one identified in an abraded landscape or seek an ultramarine to duplicate exactly what was lost in a Virgin's robe. We do not try to concoct the same type of medium used in painting the original. On the contrary, our conscious effort is to assure differentiation between what we add and the extant original, to assure that every addition we make always remains reversible. We restorers do see ourselves as only temporary custodians of our heritage; there will be others who come after us to undo what we have done, just as we have undone the work of those who lived before us.

How Far Should Inpainting Be Carried?

Good retouching isn't easy and is rarely satisfactory under every viewing condition. Take, for instance, the retouching of a loss in a blue sky. Accomplished in the north light of a restorer's studio and protected with a pleasing varnish surface, the completed treatment may gratify both the restorer and the owner who comes to collect

his painting. However, removed to a display under artificial light, the careful inpainting may stand out like a sore thumb. Color match for consistent success under the array of incandescent and fluorescent illumination in current vogue has become a serious headache for the restorer. If an owner has a fairly permanent exhibition space in mind for his painting, giving the restorer a description of its lighting might save annoyance for all concerned.

Compensation is a controversial operation. When a really damaged picture is restored, the point where compensation for loss ends and re-creation begins is hard to settle. A restorer tries his best to replace loss without interfering with the original, but what are the proper limits, and how much is enough? There are many owners and curators who feel that, except in study collections, neither they nor the public should be asked to look at stripped-down paintings. Some of these people request the exact imitation of the initial appearance. Yet when a picture is no more than a ghost of its former greatness, ravaged by neglect and abuse, any extensive additions cannot fail to add traces of the restorer's personality. Falsification is in some degree unavoidable. There are scholars who claim that an attempt to duplicate what has been lost in a ruined masterpiece deprives the viewer of that faint but inspiring quality to be found only in the residual remains. Then there are those who insist on one form or another of the limited reunification systems that vaguely harmonize compensation but do not conceal its extent. These systems include the replacement of losses with flat tones, with muted colors covered by hatch lines, with striated toning on top of monochrome fills. Certain art lovers see compensation of this kind as insulting to the Old Masters. Which procedure is the right one depends on personal convictions. As long as all compensation is executed with easily reversible materials, any form may be readjusted to suit a change in taste at no hazard to the original.

Report on Treatment

When the treatment of your painting has been completed and the surface protected with a varnish satisfactory to both you and the restorer, request that the painting be resecured in its frame with metal straps and protected with a backing board. I regret to report that this is not habitual procedure. Ask for it. You know how much it can help the survival of your canvas painting. Also ask for a report, a written and photographic record, of the entire treatment. The number and range of photographs you may receive will depend

on the habits of your restorer and to some degree on the complexity of the treatment undertaken. Absolutely requisite is the photograph taken before treatment and the photograph of the work in its stripped-down condition. Put the report where you can locate it again if the need arises, which can occur if (1) the painting should suffer an accident and you wish to make an insurance claim; (2) subsequently you have the new damage repaired, and knowledge of the materials and methods used earlier can save both time and costs; (3) you decide to lend or dispose of the painting. In the first instance, check the painting's immediate condition against the record in the treatment report so that you can compare the state on return with what you knew existed before departure. In the latter case, send the treatment report along with the painting. In a way, your treatment report is your painting's passport.

Enjoy Your Paintings

Friends often complain that our viewpoint of concern for the physical well-being of paintings interferes with our appreciation of their beauty. This is absolutely not true. If we come upon a painting cold-bloodedly hanging on some public wall in a state of great distress, yes, we have made outcries. But I cannot believe that the kind of intimacy we encourage with paintings leads to anything but an even happier relationship. Just as horticulturists love their gardens, and parents with better understanding feel deeper sympathy with their children, owners who are familiar with the structure and behavior of their paintings develop a warmer attachment to them. There is so much more to see and to watch over than you ever suspected. You may find yourself carrying the weight of a new responsibility but will also have a great deal of pleasure in your ability to provide knowledgeable protection. Your painting is at times as helpless as a newborn babe and as fragile as an ancient monarch. It can look only to you for its survival. You wouldn't own it if you didn't love it. Its care becomes a source of additional enjoyment.

Index